To Lee & Kenneth —

J Michael Bell

<u>Charles F. Stanley, In Touch Ministries</u>

"Michael's images are astounding – capturing the stories and parables of the New Testament in wonderfully creative and imaginative ways. They challenge how people think about Jesus by how they combine modern elements and people within them. I know that God will use this body of work to draw many people to Himself and open their eyes to their need for the Savior. What a powerful way to communicate the gospel and glorify Him. From these photographs, I can see how profoundly Michael loves the Savior and how he has dedicated his life to Him. May God bless this project as it continues to serve Him through Journeys with the Messiah. "

<u>Steve Davies, Senior Pastor, Village Baptist Church</u>

"Never has an artist been so compelling in their presentation of the truth. Michael has been gifted by God! Journeys with the Messiah is inspired, exciting and challenging. Michael takes those who choose to walk this realistic journey with Jesus through the valleys and mountaintops of emotion, through the depths of the gracious love and care of the Messiah and through the anguish and cost of His sacrifice. Those who see it will be forever changed. "

<u>Emmy Cerveny, Wife of the Sixth Episcopal Bishop of Florida</u>

"I saw afresh the power of the Risen Christ at work in our daily lives if we but slow down and listen; surrender and trust in Him. I thank the Lord for using Michael in a mighty way! My faith was renewed and my motives challenged as I viewed these fine works of art. The world is hungry for this fresh approach and this new way of viewing these ancient truths from scripture!"

<u>Liesel Schmidt, Editor, Coastal Christian Magazine</u>

"What began with a simple question, a camera, and a willingness to serve, has become so much more—a ministry that has touched countless lives in countless ways. And the journey is far from over."

<u>Jeff McDonald, Managing Editor Salvation Army National Publications</u>

"In my 25 years as an editor, I have seen many attempts to bring Jesus into a modern environment. Yet, I have not seen it done nearly so effectively and convincingly as in your images. The images are stunning, totally believable and of great impact. For those of us who strive to communicate the Gospel and the presence of Christ in the modern world, your images are refreshing and brilliant."

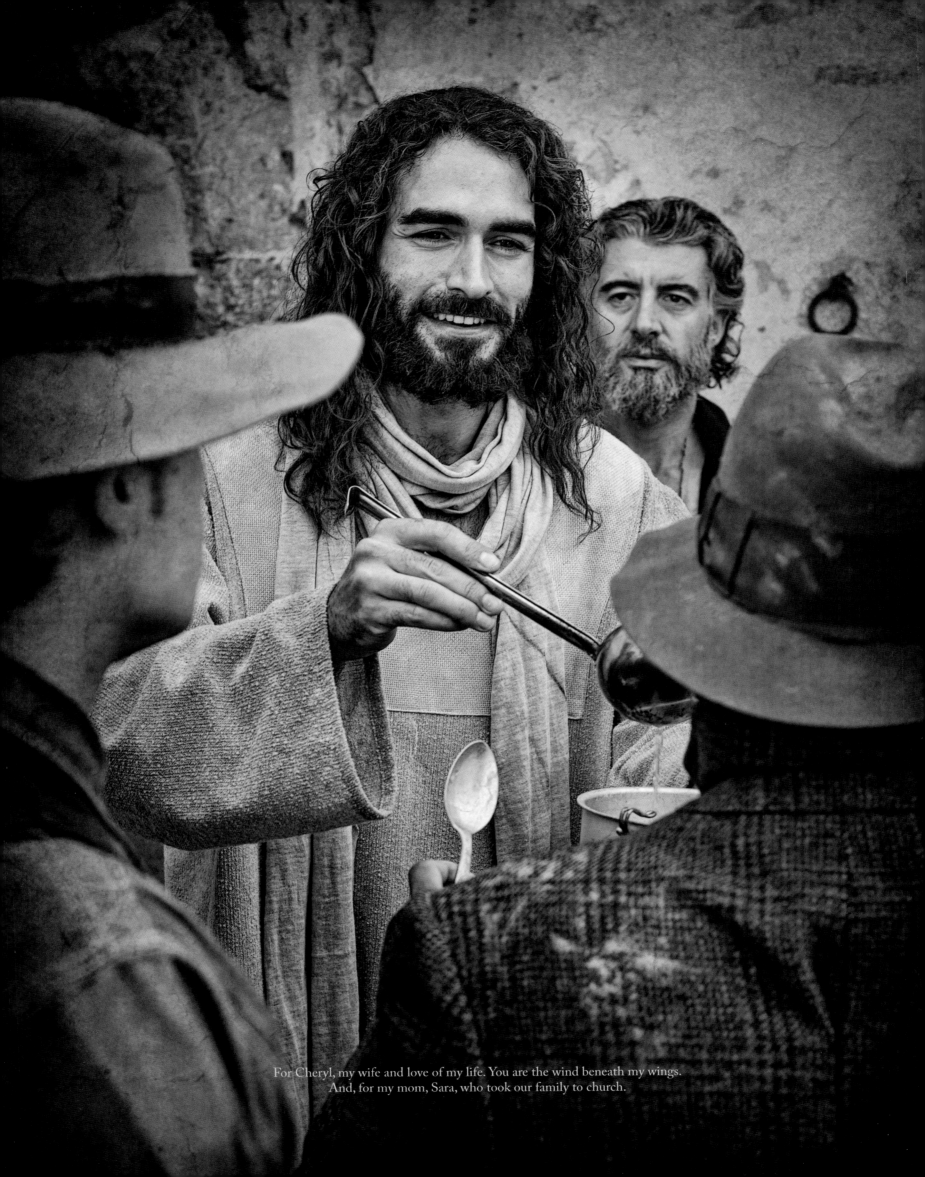

For Cheryl, my wife and love of my life. You are the wind beneath my wings.
And, for my mom, Sara, who took our family to church.

Journeys
WITH THE MESSIAH

A Fashion Photographer
Explores the Modern-day Relevance
of Jesus' Centuries-Old Message

PHOTOGRAPHED AND WRITTEN BY MICHAEL BELK

Journeys with the Messiah
A Fashion Photographer Explores the Modern-day
Relevance of Jesus' Centuries-old Message.
Photographed and Written by Michael Belk

First published in the United States in 2009
1st Reprinting 2010
By Journeys with the Messiah, LLC
174 WaterColor Way, Suite 111
Santa Rosa Beach FL 32459
USA
www.thejourneysproject.com
Photography and text © 2009 Michael Belk
ISBN Number 978-0-615-29599-2
Library of Congress Control Number: 2009929246

Printed in the United States

TABLE OF CONTENTS

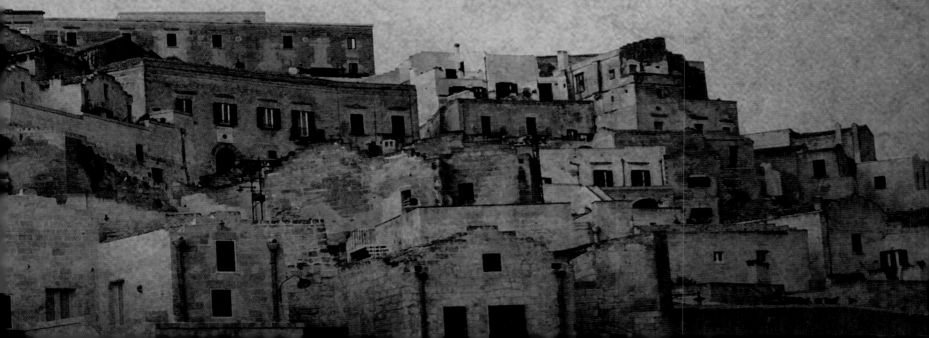

INTRODUCTION

"*What* are you doing with all that I gave you?" When I read those words in The Purpose Driven Life, they resonated with me. Yet, they were not new. During my years as a fashion photographer - with privileges most people can only dream about - that question had begun to surface. Why was I allowed this wonderful life? Was there more expected of me?

Photography had become a passion after college while I was a salesman for a leading manufacturer of men's clothing. My camera was my companion during the five years we traveled the highways of the southeast visiting clients.

Life has defining moments. My first one came at age 28 with the idea of combining my limited photographic skills with the knowledge I had gained in the fashion industry. With no experience in fashion photography, I boldly (or foolishly) arrived in New York City to pursue clients. With some salesmanship, a bit of marketing savvy and many instances of "being at the right place at the right time," my efforts were rewarded. Over the next years, I evolved from photographer to head of my own fashion-advertising agency. It was a challenging and exciting career that took me from the streets of Paris to the Outback of Australia.

By 40, I was at the peak of my "game" and enjoying the success that came with it. I could be in Hawaii on a photo shoot and, the next day, I might be in Manhattan for a meeting. The pace was addictive and, truthfully, I loved it. Yet, no matter how great my life appeared on the outside, something was missing on the inside. Eventually, the pace took its toll.

Exhausted, I physically and mentally "crashed and burned," spiraling into a dark abyss of fear and panic. For weeks, I could not sleep and went AWOL from work. The more I tried to get out of this darkness, the darker it got. By myself, I was not getting out of this dilemma. I was about to experience the biggest defining moment of my life.

Despite the evidence around us, many do not recognize that "God is good." Most of us travel the "highway to hell" until we recognize that "our plans" for life do not work. While in this "dark abyss," perhaps God decided that I had traveled far enough. For whatever reason, He came for a visit as casually as a friend dropping by for a cup of coffee. *"What now, Michael?"* He asked. *"Do you want to continue down your highway or would you want to give My plan a try?"*

I confessed that I had squandered much of the life He had given me, living it all for myself; that I had no clue how to run my life and that I would like to give His plan a try. He told me to sleep. He would stand watch for the night.

When I awoke the next morning, my world was not restored nor was everything rosy. However, a change was underway and the journey to know my Lord and Savior had begun.

Although I grew up in the church, I had not been a follower of Jesus or knew much about Him. Now, as I began to seek Him, I found His story and message fascinating. Two thousand years ago, Jesus began to teach a revolutionary message about the nature and will of God and the eternal Kingdom of Heaven. His journey was brief, ending in His brutal death just three years later at the age of 33. Yet, the purpose of His journey and the power of His story have continued to impact, and divide, mankind throughout history. What could one man say that would have such an impact? I wanted to find out.

So, during the past twenty years, I have invested time learning about His significance in the world, understanding His role in the grand scheme of all things and, in particular, understanding who He is in my life. I have forged an enduring relationship with Him - a relationship that has positively impacted my life now and for eternity.

So how is it that we have become so divided over the person of Jesus? Not only has our world divided into a host of

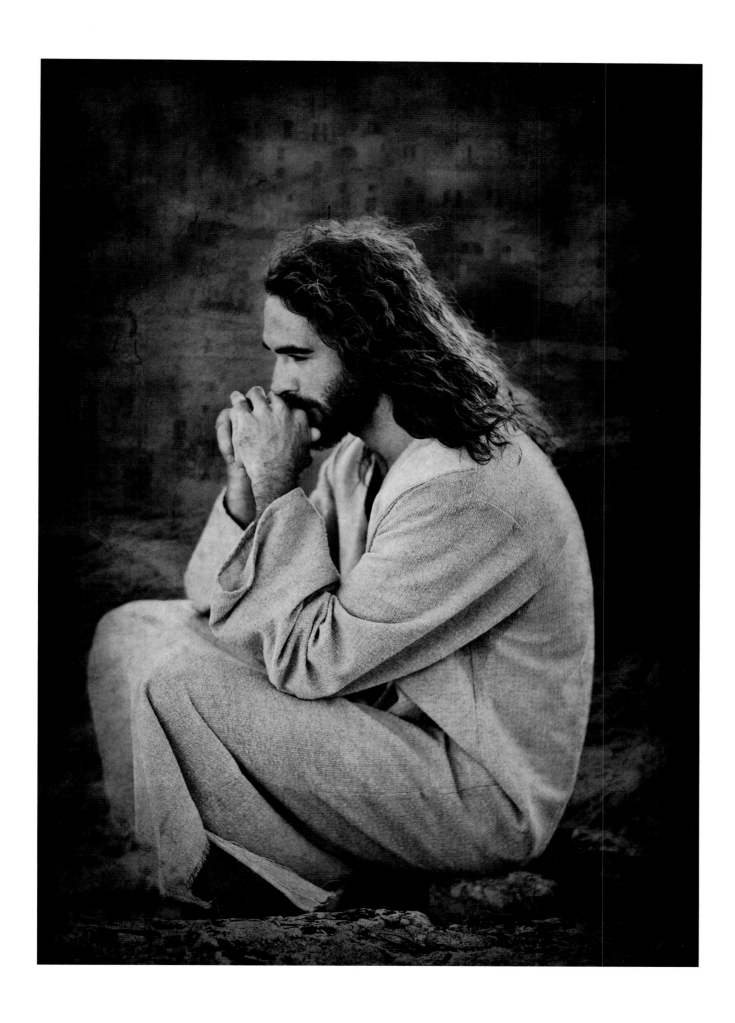

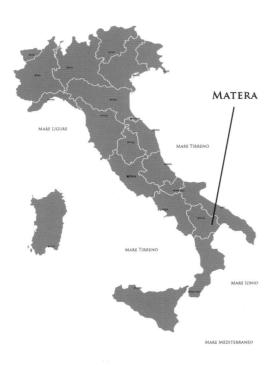

MATERA

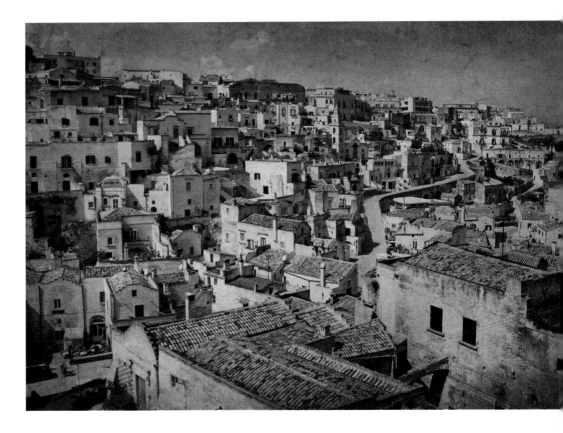

religions - Muslims, Buddhists, Hindus and others – it has drawn a line between Christians and non-Christians. The Christians have also separated into Methodists, Baptists, Catholics, Presbyterians and many others based on theological interpretations. And, let us not leave the Jews out of this conversation. They are a people, a nation and a religion. And, like the Christians and other religious groups, they too have divided into "versions" of their faith.

Yet, Jesus did not come to start a religion. He came to start a revolution - a revolutionary way of living through our understanding of God's plan for mankind and, specifically, our lives. Jesus did not come to usher in the Methodists or the Muslims, the Baptists or the Buddhists. He came to "testify to the truth" of God's holy nature; to teach us, and to show us, how to follow His "plan of hope" so that we may enjoy life now, with Heaven and eternal life thrown in as a bonus at the end. He came for all people, from all nations, regardless of their religious beliefs.

Unfortunately, as these "religious movements" have held tightly to what they believe is the proper interpretation of his message, I believe the essence of the real Jesus is often distorted, leaving His message lost to many and hidden from others.

Some people know Christianity from their childhood days in church, while others may know only what they see on television or read in newspapers. Some may have a perception of Jesus based on someone who claimed to be a Christian, but whose actions appeared to be contrary to His teachings. Some have too harsh a view of Jesus, others too soft. And, many will join the conversation, repeating only what they have heard from others, then give an opinion as if it were their own, never knowing if what they say has any merit.

My desire is for you to put aside the past and any unsubstantiated ideas you may have about Jesus and simply listen to what He has to say. Although many will experience great emotions as the truth of Jesus is revealed, one can come to many conclusions about Him just by considering the facts that are backed by volumes of indisputable documentation regarding His life.

I have examined those facts with my mind, sought the truth with my heart and come to the only conclusion available that makes sense to me. Now, as a privileged follower of Christ, I have been given the creative talents with which to share my conclusion in these unique images and messages. My prayer is that you will open your heart to hear whatever Jesus may have to say to you.

Journeys with the Messiah has been a natural progression. For many years, I sensed that God had plans for me beyond my career as a fashion photographer. That question, "What are you doing with all that I gave to you?" began to weigh heavy on my soul.

In 2004, I opened a gallery in a resort in Santa Rosa Beach, Florida. It was a peaceful place and I thought it could be a sanctuary for vacationers to come for a moment of quiet and, "What if all of the images depicted messages of Christ!" Over time, this idea grew.

In 2006, I heard Bruce Wilkinson speak on his book, *The Dream Giver*. He talked about the dream that he believes God places on each person's heart and how we remain restless until we uncover it. This message spoke deeply to my soul.

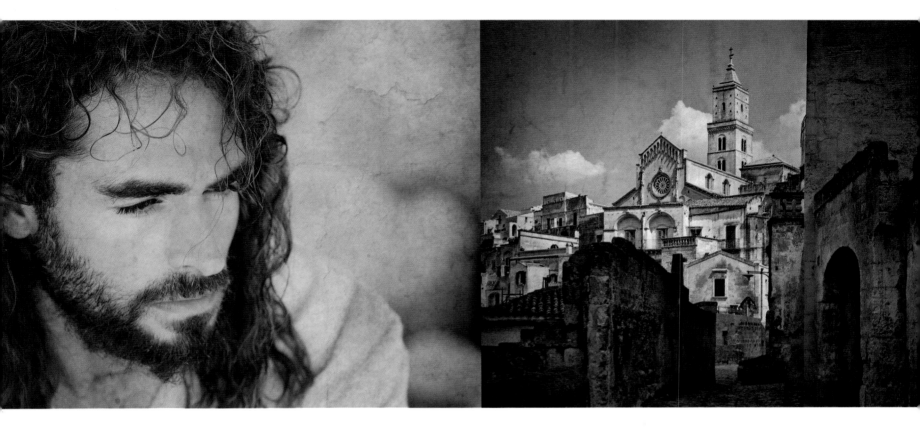

So, I began to tell everyone about the dream that God had placed on my heart.; the dream to create a collection of photographic images depicting the messages of Jesus; messages I wanted to share with others. I reasoned that, if people could see Jesus as I had, they would not fear Him, but passionately embrace Him. Plus, it seemed to me that many, who said they "knew" Him, who said they were Christians, were limiting Him to Sundays and emergencies, missing the joy of knowing Him every day.

In 2008, about to turn 60, I asked my wife, Cheryl, "What if I die and have not created this project? How will I explain it to God? He had trained me for thirty years and provided the time, talent and financial resources. What would I say, "I had good intentions and then I died! We agreed that it was too risky not to get started. So, I closed the gallery and put my career on hold.

When God challenges us to a journey like this, I am convinced He does not take the first step. Yet, once I took the "leap of faith," He took the next step by revealing to me the ancient town of Matera, Italy. Matera's ancient appearance looks like how I would imagine 1st Century Jerusalem. It would be the perfect backdrop for my images. The journey had begun!

The next months were filled with research and planning as I sought God's vision for the images. By August, plans for the project had outgrown the budget and our producer in Italy advised that the photo shoot would cost three times our original estimate. Cheryl and I agreed that there was no turning back. Then again, we had no idea that the stock and housing markets were about to crash taking

our life savings with it. Suddenly, our project had a new dimension. It would become "Our Journey with the Messiah;" a journey to trust in God's provision, since we could no longer trust in our own.

We arrived back in Italy in early October 2008 to begin production. No adventure in my entire career could compare with what I was about to experience.

Now, I knew that I could create great images, but I wanted more. The images had to be divine if they were to touch people's hearts. So, from the beginning, I told God that I would bring the camera. He would have to come to Italy and make them Divine.

Now, with these unique images and timeless messages, it is my desire to portray the character and significance of Jesus Christ from a fresh, innovative and inviting perspective. And it is my prayer that they will ignite or re-ignite a passion in you to know more about Jesus, who is accepted by many as the Messiah, the Son of God. Whenever I share His messages, even in a "non-religious" context, it has been my experience that people find them to be comforting, enlightening, full of hope and often challenging. Through *Journeys with the Messiah*, I am compelled to share with you the powerful messages Jesus has shared with me.

J. Michael Belk
Santa Rosa Beach, Florida

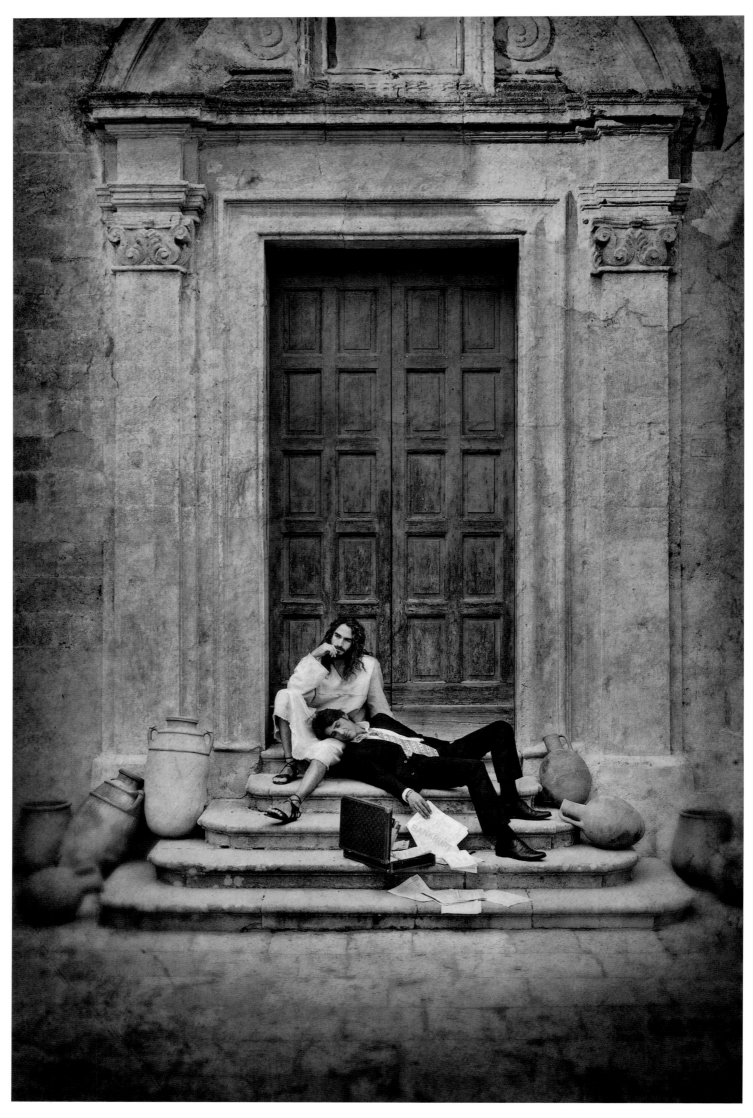

Rest for the Weary
Time out from the burdens of life.

As I write this in March 2009, the world is in the midst of serious economic upheaval. Fortunes have been lost, retirement incomes are gone, and, for many, the basic necessities have become a struggle.

It is at times like these that I recall the simplicity of childhood and the safety of my parents' arms.

In truth, we assign too much importance to issues that, in the end, will be of little consequence. Have you ever heard of a man on his deathbed asking to see his stock portfolio one more time? Perhaps, instead of worrying, we could spend our time in quiet solitude with Him, the One who created it all and promises more?

Like any good parent, Jesus promises that He will *"never leave us or forsake us."* And, He commands us not to worry about anything, but to *"seek His Kingdom first,"* allowing His Father to generously take care of our needs. He invites *"all who are burdened and weary"* to come and find rest in Him.

It is a great offer. Maybe we should give it a try.

Matthew 11:28

MAKEOVER

Let the Master Artist reshape your life.

*D*o you recall the vivid imagination you had as a child? Wonderment was everywhere and pleasure was found in the simplest of things. Yet, somewhere along the way, we lost our natural instinct of doing what we liked to do and fell into the trap of doing what we needed to do. Over time, we designed our lives only to have our designs consume us.

Throughout the Bible, God offers a delightful alternative, *"For I know the plans I have for you and they are good plans of hope and a future."* Yet, why would be believe that God, who created every sunrise and sunset, would know what to do with us? So, we never ask. And therein lies our struggle. Our rigid plans can lead us to resist God's shaping the "clay" of our lives.

Jesus wants us to surrender to "what we think we desire for our lives" and let Him mold us into the greatness He desires; a life, so beautiful, we could never conceive it on our own.

Jeremiah 29:11-13

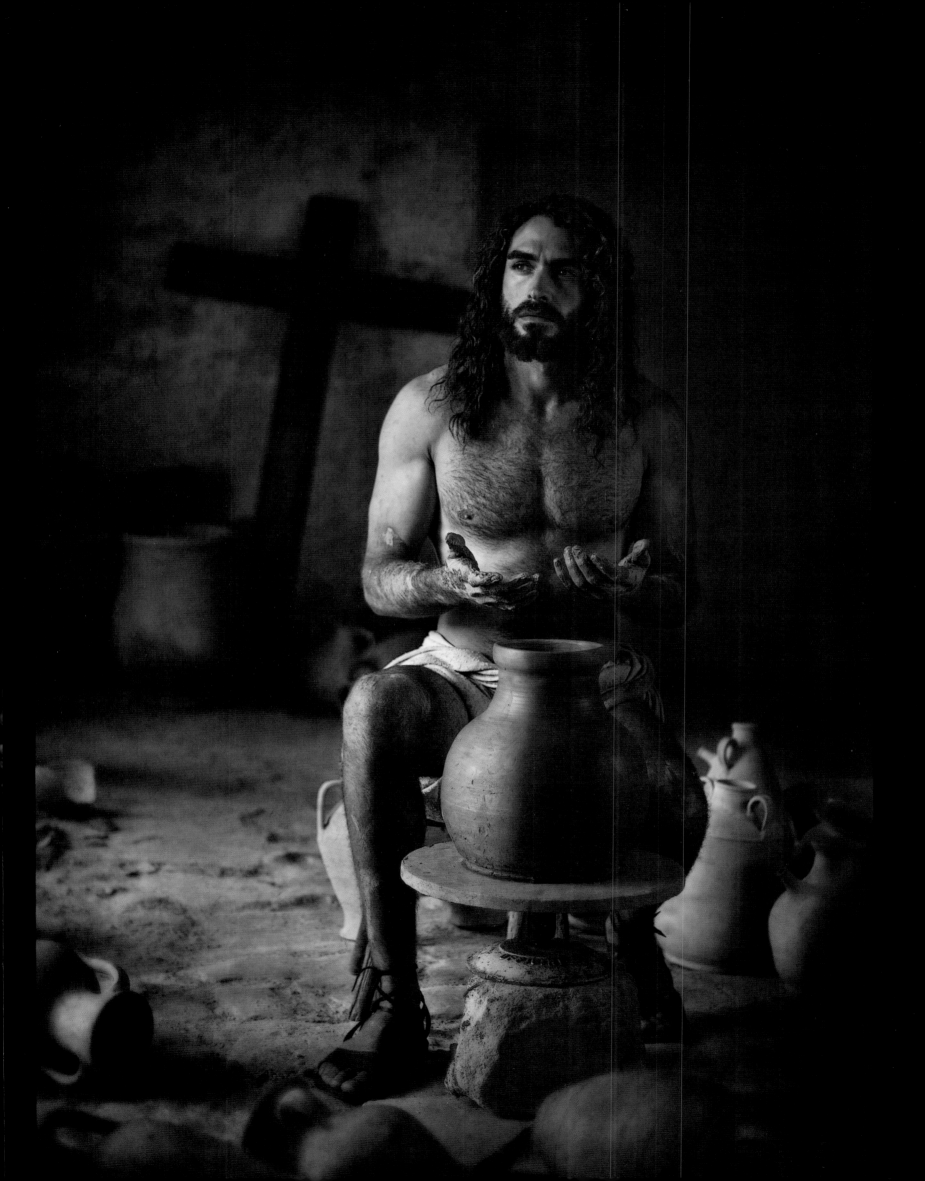

CAN'T TAKE IT WITH YOU

A lesson on retained earnings.

*A*t a news conference after the death of John D. Rockefeller, his attorney was asked how much money the wealthy industrialist had left. His response was, "He left it all."

In the 39th Psalm, King David offers these words of wisdom, *"Lord, remind me how brief my time on Earth will be. Remind me that my days are numbered…(that) all our busy rushing ends in nothing. We heap up wealth, not knowing who will spend it."*

And, in the story of the rich man who planned to tear down his barns to build bigger ones to store his wealth, God called him a fool, saying that his life would be taken that night.

Jesus knew that money would be a stumbling block for everyone. That is why He talked more about money and possessions than He did of Heaven and Hell — never saying that money was evil, only that it could become the master you serve rather than the One who offers the greatest gift of all.

Luke 12:16–21

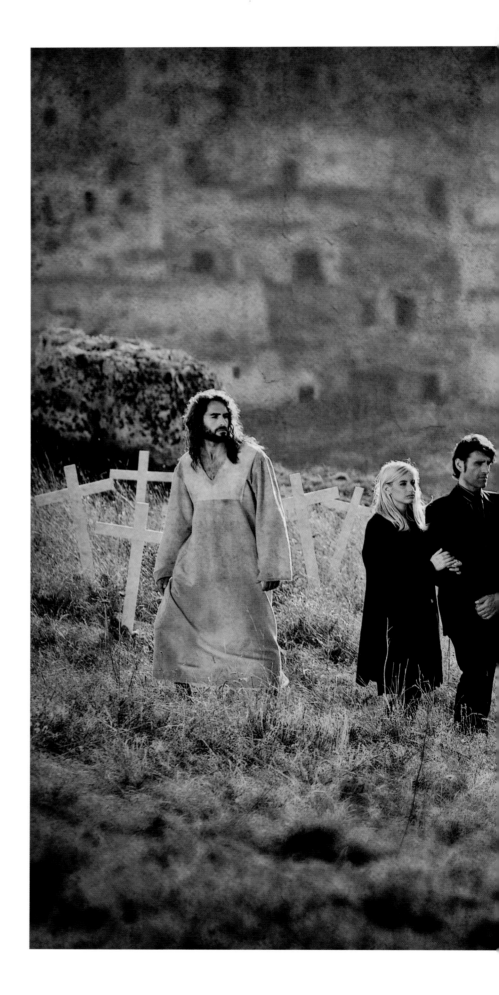

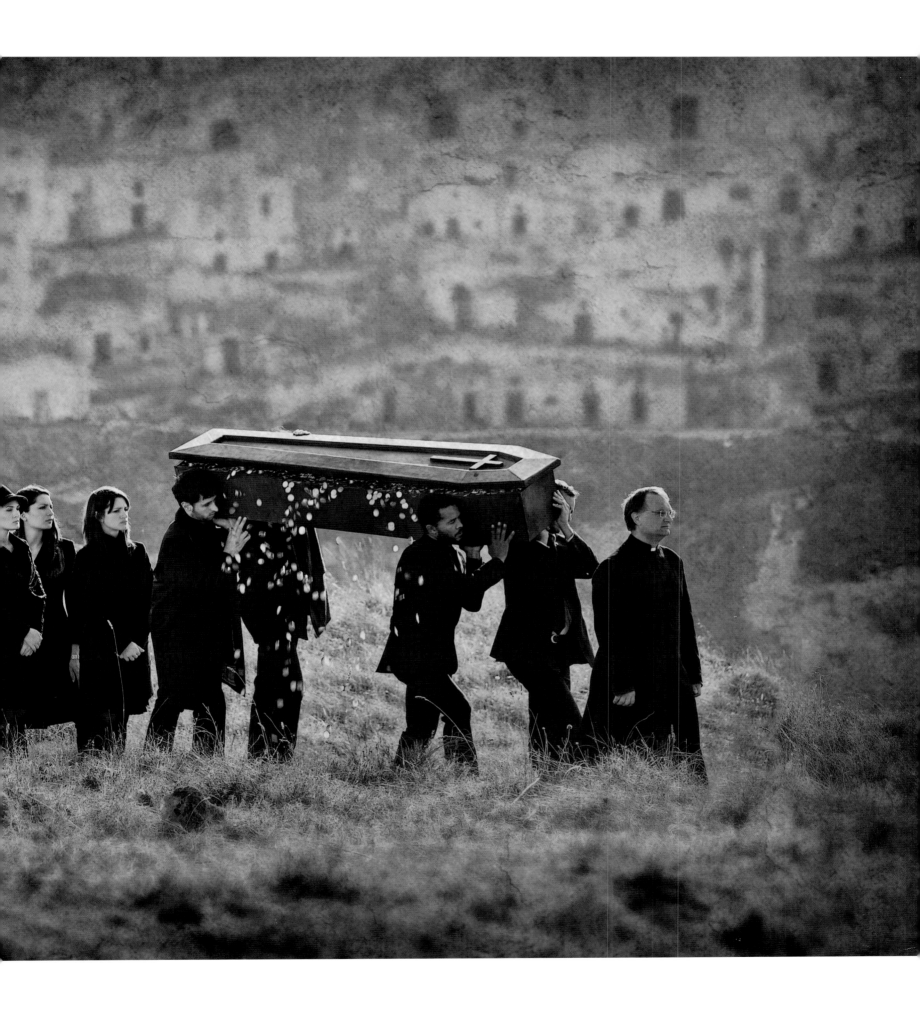

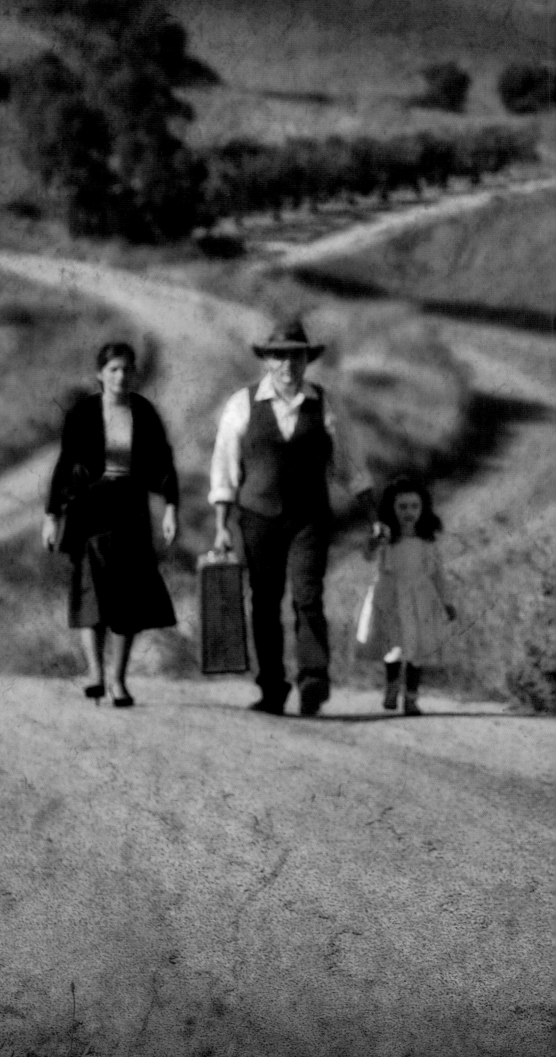

LIGHTEN THE LOAD
Support for when life is weighing you down.

*W*ho among us is without burdens? From a delayed flight to a late mortgage payment, a term paper due on Friday or a seriously ill family member, all of us have times when we are disheartened and discouraged along our way, sometimes to the point of "spiritual bankruptcy."

Jesus sends an invitation: *"Come to Me all who labor and are heavy laden and I will give you rest… For My yoke is easy to bear, and the burden I give you is light."*

I know a unique word not found in the dictionary: "Efforting." It means struggling unnecessarily in an effort to do something. It could be illustrated by pushing a car to your destination when it would be much easier to start the engine and drive it.

When I find myself "efforting," I think of Jesus' invitation to let Him take the heavy part of the yoke, leaving me the lighter side. He does not necessarily say that He will carry all of my baggage. Yet, He does promise that when we accept His invitation, He will gladly lighten our load.

Matthew 11:28–30

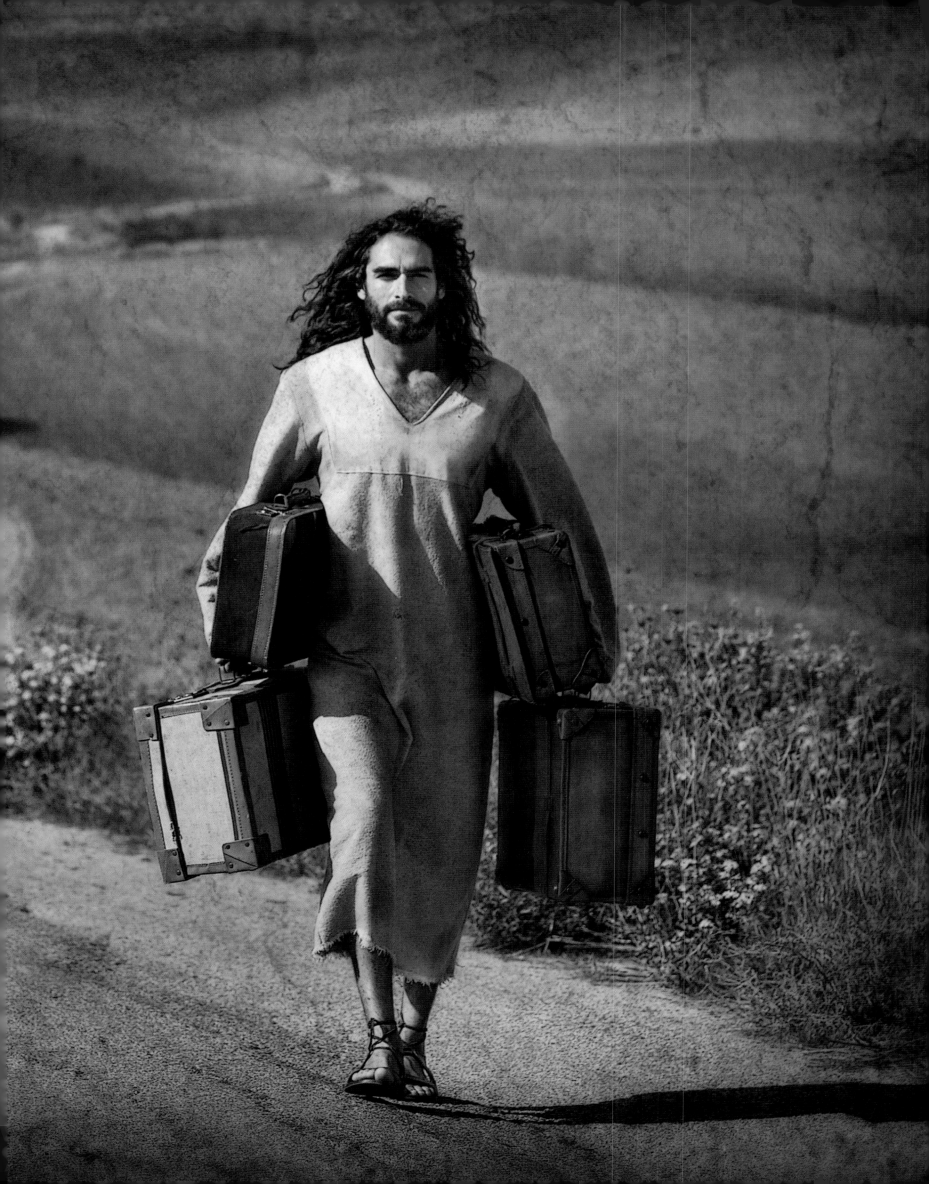

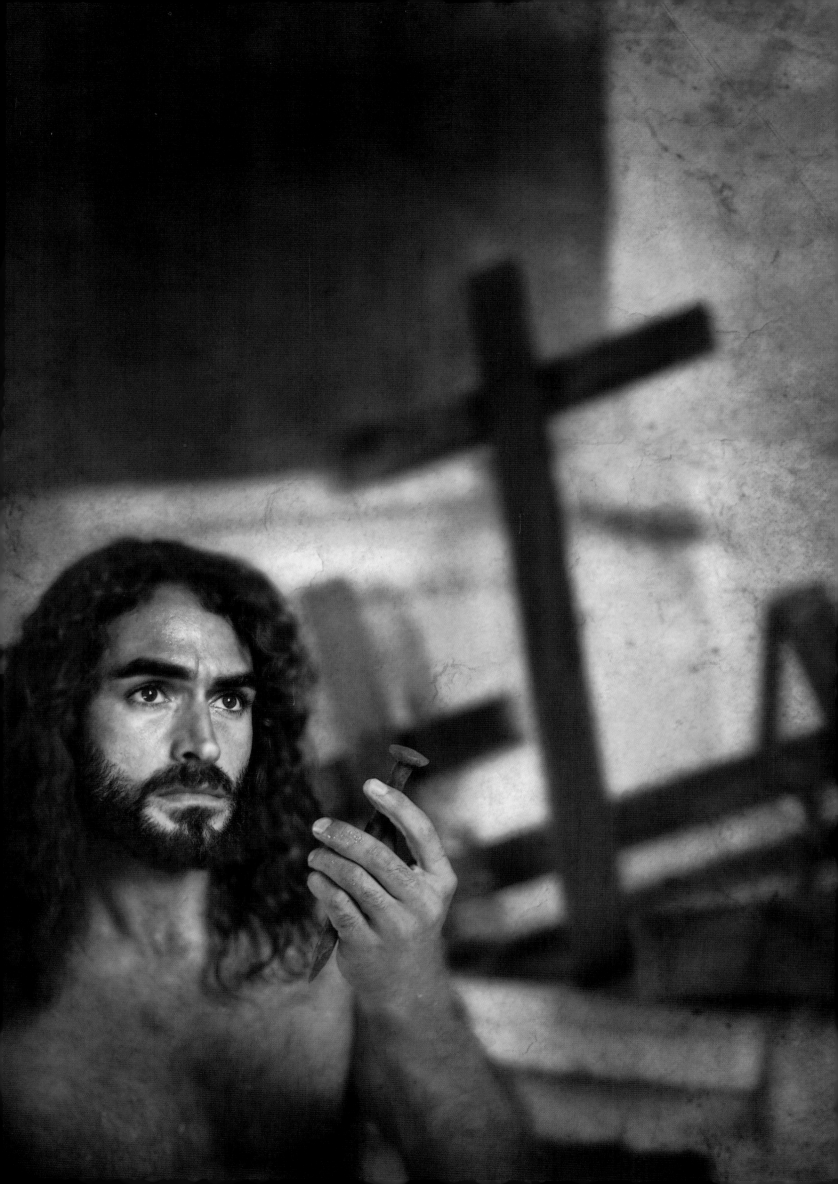

Messiah VII

Our life on Earth is a journey that takes us to the pinnacles of success and the valleys of despair. If you have not been to both, it is difficult to appreciate either.

Jesus experienced every emotion we have experienced, but to a much greater degree. And, although his death on the cross appeared, at first, to be a "defeat," it was ultimately the greatest triumph we - and the world - will ever know.

His victory is our victory -giving meaning to our lives and making them well worth the journey.

GONE ASTRAY
Knowing a shepherd worth following forever.

A conversation with a shepherd may help us to understand why Jesus used sheep as a reference to people. Like humans, sheep are instinctively fearful and resist change. They have to be led to food and be protected from predators. They like to gather together, but will wonder away from the flock when not paying attention. And, a few sheep can lead the others astray.

Thousands of years ago, the prophet, Isaiah, was describing us when he wrote: *"All of us, like sheep, have strayed away. We have left God's path to follow our own, straying from what is right."*

So, why is it we leave God's path to follow our own? Is it because we think the grass is greener on the other side of the hill? Is it because we are content; that is, until we get into trouble? Or, are we just so misguided that we think that following our own path is somehow better than the one God has planned for us?

Today, shepherds herd sheep. But in Jesus time, the shepherd led his sheep. Jesus is The Good Shepherd of the 23rd Psalm who leads me to green meadows and beside still water, renewing my strength and restoring my soul. Who comforts and protects me in the darkest valley and fills my life with blessings until it overflows. And, He is the one who leads me back to God's path when I stray away on my own.

With a Shepherd like that, I have all that I need.

Isaiah 53:6

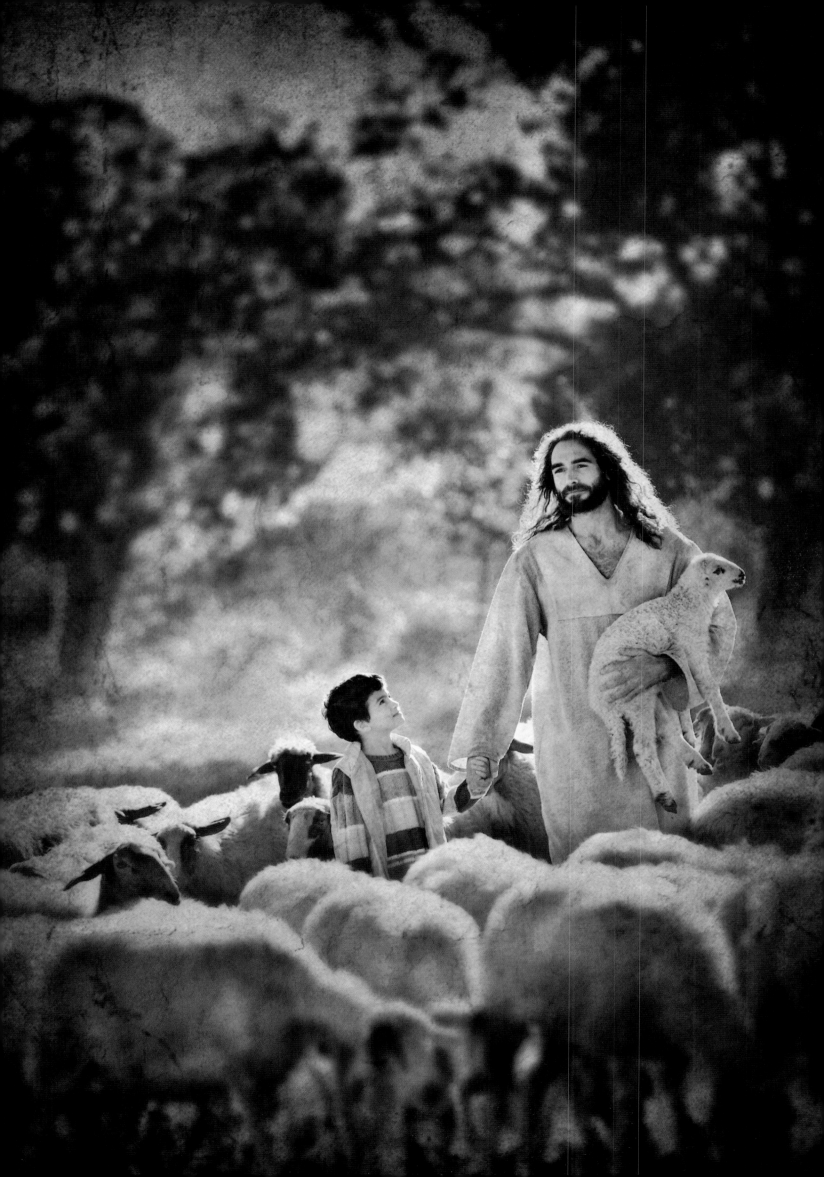

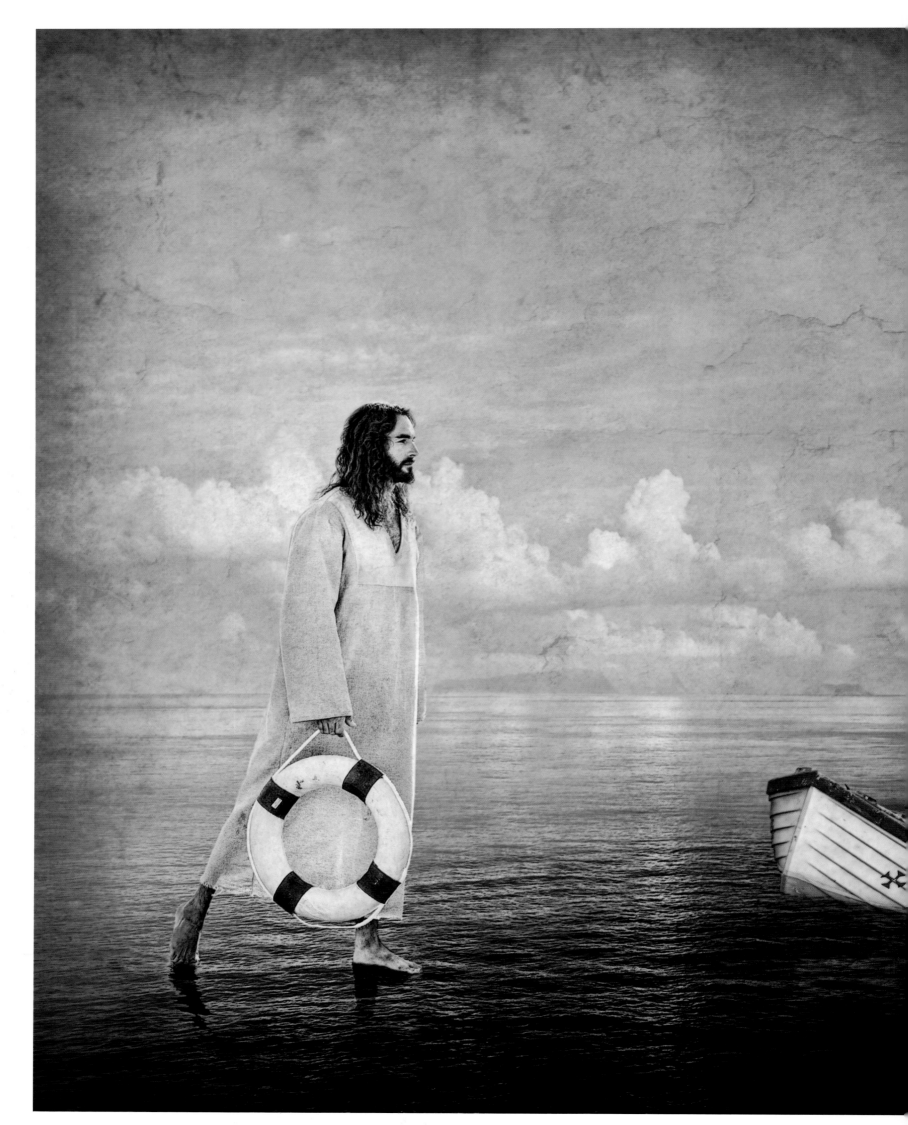

LIFE SAVIOR

Swimming lesson for the spiritually inclined.

*M*any years ago, on a blustery day, I headed out for a late afternoon walk on our beautiful beach. As I approached the water, I heard the frantic cry of children.

Without fully considering the situation, I leaped into the water and, within a split second, found myself fifty yards off shore caught in a riptide and staring into the desperate faces of three small boys and their fathers. Riptides are strong currents that can be deadly if you do not know the simple rule for getting out of them.

Isn't that how life is? We go out for a quiet walk on life's beautiful beach when disaster unexpectedly hits and we find ourselves in a circumstantial riptide and drowning in life's trouble.

Like the riptide that allows you to escape by simply swimming parallel to the shore, there is a Life Savior always available to save us from the perils of this world. Not only can Jesus throw us a life saver when we get in over our heads, He offers free spiritual swimming lessons that will help keep us out of trouble to begin with. He is a life savor and our Ultimate Life Savior.

John 6: 16–21

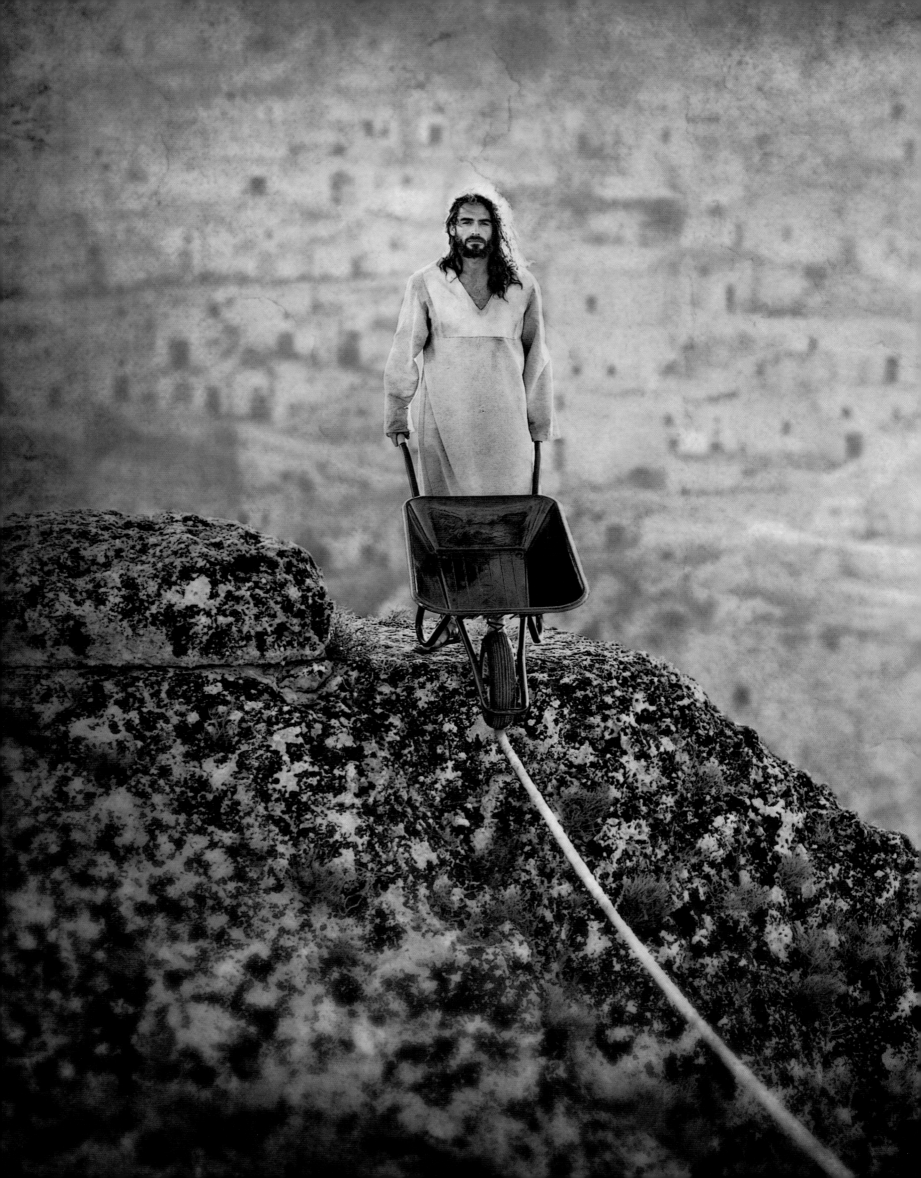

FAITH & TRUST
Having our faith carried to new heights.

A traveler, hiking through the wilderness, came to the edge of a canyon. Seeking a way to the other side, he discovered a big rope stretched across the canyon. As his eyes followed the rope toward the other side, he was surprised to see a man coming toward him, confidently pushing a wheelbarrow. As he arrived, the traveler exclaimed, "That was truly amazing!"

The man with the wheelbarrow asked, "Do you believe that I can do it again?"

"Oh, of course," the traveler replied. "You walked across with such confidence."

"Do you really believe I can do it again?" asked the man with the wheelbarrow.

"Definitely," replied the traveler.

"Very good, then," said the man with the wheelbarrow. "Hop in and I will take you across."

Many of us look at God the same way we look at the man with the wheelbarrow. We say we have faith that God can do anything. Yet, when it comes time to get in the wheelbarrow, our faith begins to dwindle.

The scriptures are full of stories of faith and trust. The blind man, Bartimaeus, had such faith in Jesus that he was given sight. Jairus' faith resulted in the healing of his daughter and the woman, whose faith made her relentless in her pursuit to touch the hem of Jesus robe, received healing.

Are we relentless in our pursuit of Him? Or, do we stand at the edge of the canyon wishing we could get across? Having experienced so many of God's promises, surely we can trust Him to carry us across this tightrope we call life.

Matthew 17:20

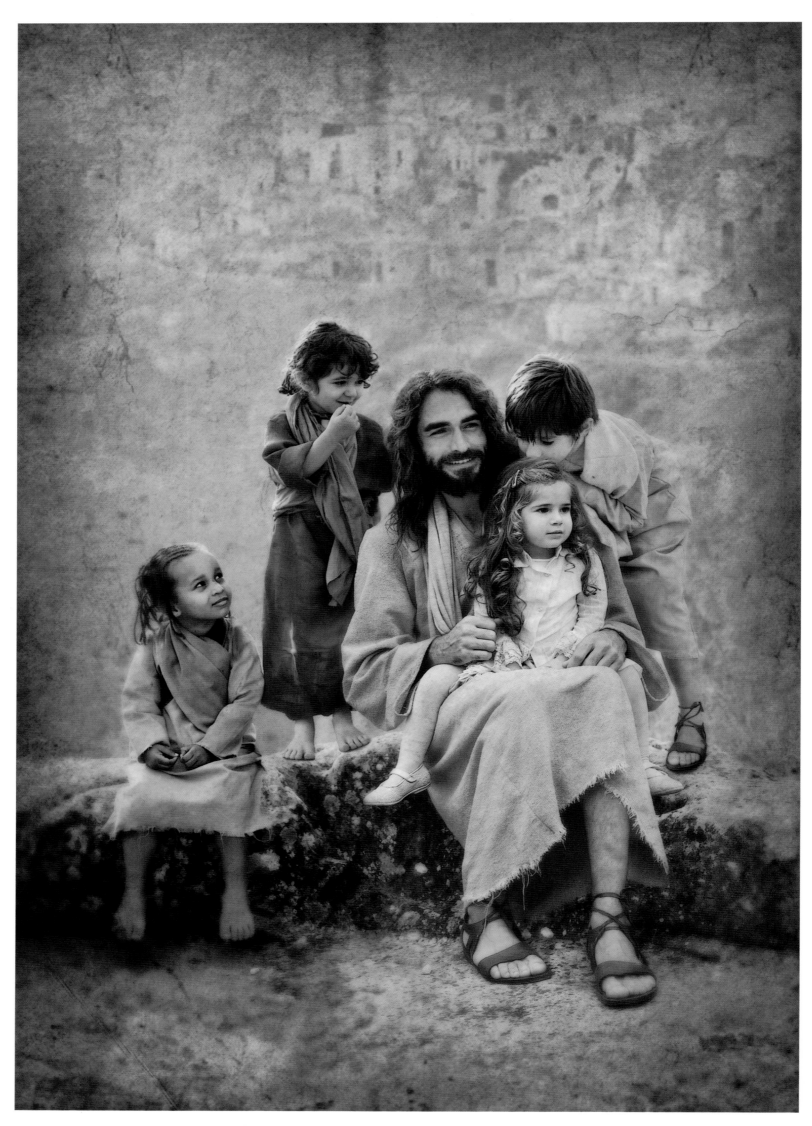

RAGAMUFFINS
Accepting a gift with humility.

When Jesus said to His followers, *"To enter the Kingdom of Heaven, you must come as little children,"* I just assumed He meant because children were innocent. Then, reflecting back on my time as a child and times I have watched my own children or others playing, I could only conclude that "their innocence" was not the virtue to which Jesus was speaking.

Children were loved in the first century. Yet, unlike children today, the world did not revolve around them — gifts for every occasion, birthday parties and trips to Disney World. Children were more humble, having fewer expectations than children today.

The Kingdom will be a gift to people who know they are not worthy of such a gift — *"the poor in spirit"* — the people who are not trying to impress others or position themselves where they will look good to the King. Thus, *"Come as little children"* means come to Him in humility, expecting nothing, knowing that grace and salvation come as His gift - a treasure we are incapable of obtaining on our own.

A relationship with Christ will always be more about the gift that we receive rather than what we give up.

Mark 10:13-15

Messiah IV

Everyone has, or will have, "a cross to bear;" a heavy burden of responsibility or a problem for which they alone must cope. Some last a lifetime. Others are temporary. Yet, as difficult as our burdens may be, Jesus promises He will never leave us, never forsake us and will help each of us carry our cross into eternity with Him, where we will bear them no more.

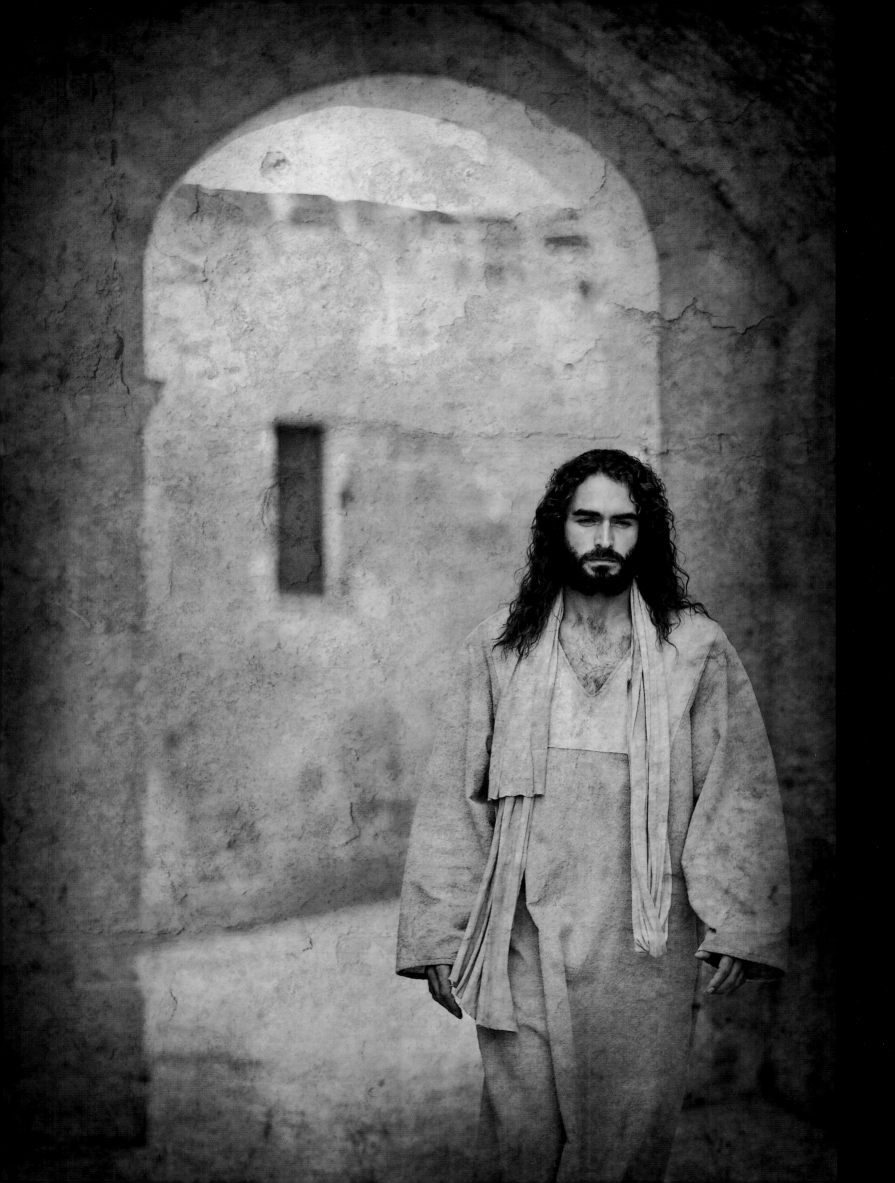

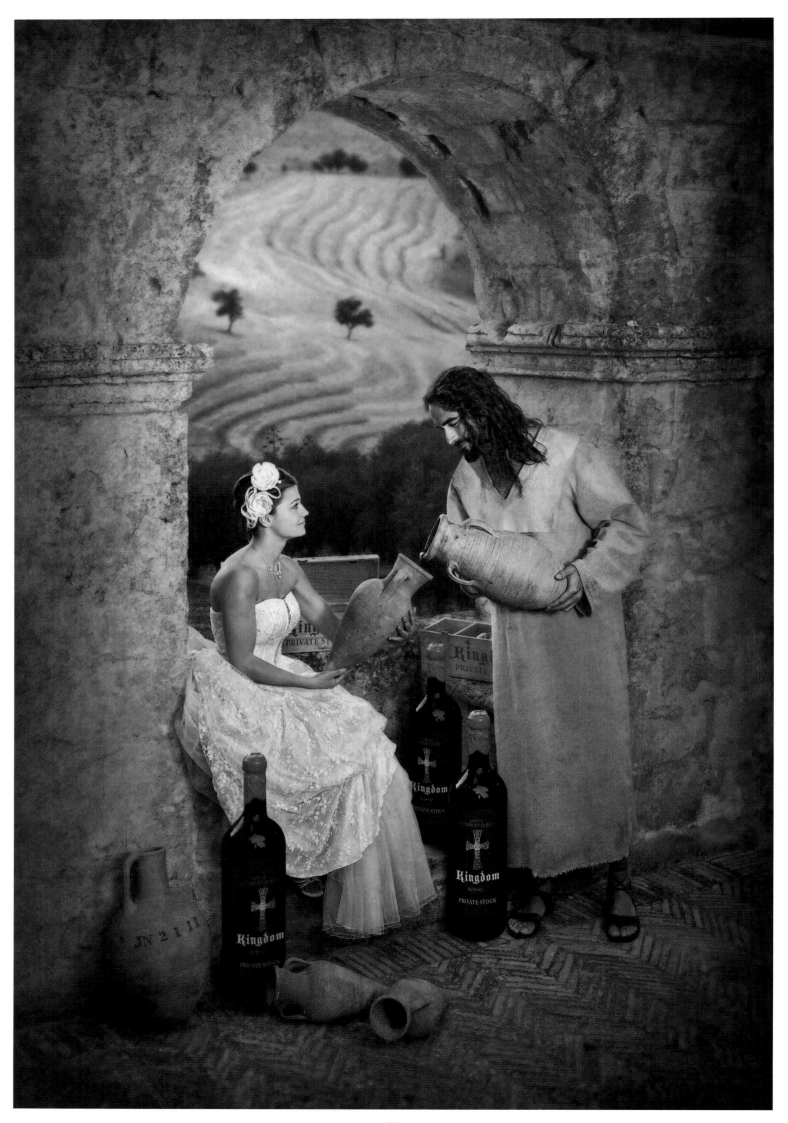

THE BEST IS YET TO COME
Your best life is just over the horizon.

*O*f Jesus' many miracles, one of the best known is when He turned water into wine at a wedding in Cana.

Running out of wine at a wedding was an unacceptable social blunder. At the wedding celebration in Cana, such a situation was about to embarrass the bridegroom.

Then, at the request of His mother, Jesus set about saving the day. Taking several pots that were normally used for ceremonial cleansing, he filled them with water and then, miraculously, turned the water into wine and served some to the master.

It was exceptional wine, prompting the master to exclaim to the bridegroom, *"Most people serve the good wine first and when the guests have had a lot to drink, he brings out the less expensive wine. But you have saved the best for last."*

What a great message to us: Jesus' miracle not only reiterates His promise of provision…we will not run out of wine… it reveals that the wine we drink now is the "cheap wine" compared to the wine in His Kingdom to come.

When we let go of this secular world and grasp the promises of Heaven, we will understand that He has certainly "saved the best for last."

John 2:1–11

SASSI DI MATERA

Located southeast of Rome in the Basilicata region of Italy near the Adriatic Sea, Matera could not have been a more perfect backdrop for our images that depict a 1st Century Jesus in what appears as a 1st Century setting. Matera has gained international fame for its ancient town, the "Sassi di Matera" (meaning "stones of Matera"). The Sassi originates from a prehistoric settlement, and are suspected to be some of the first human settlements in Italy.

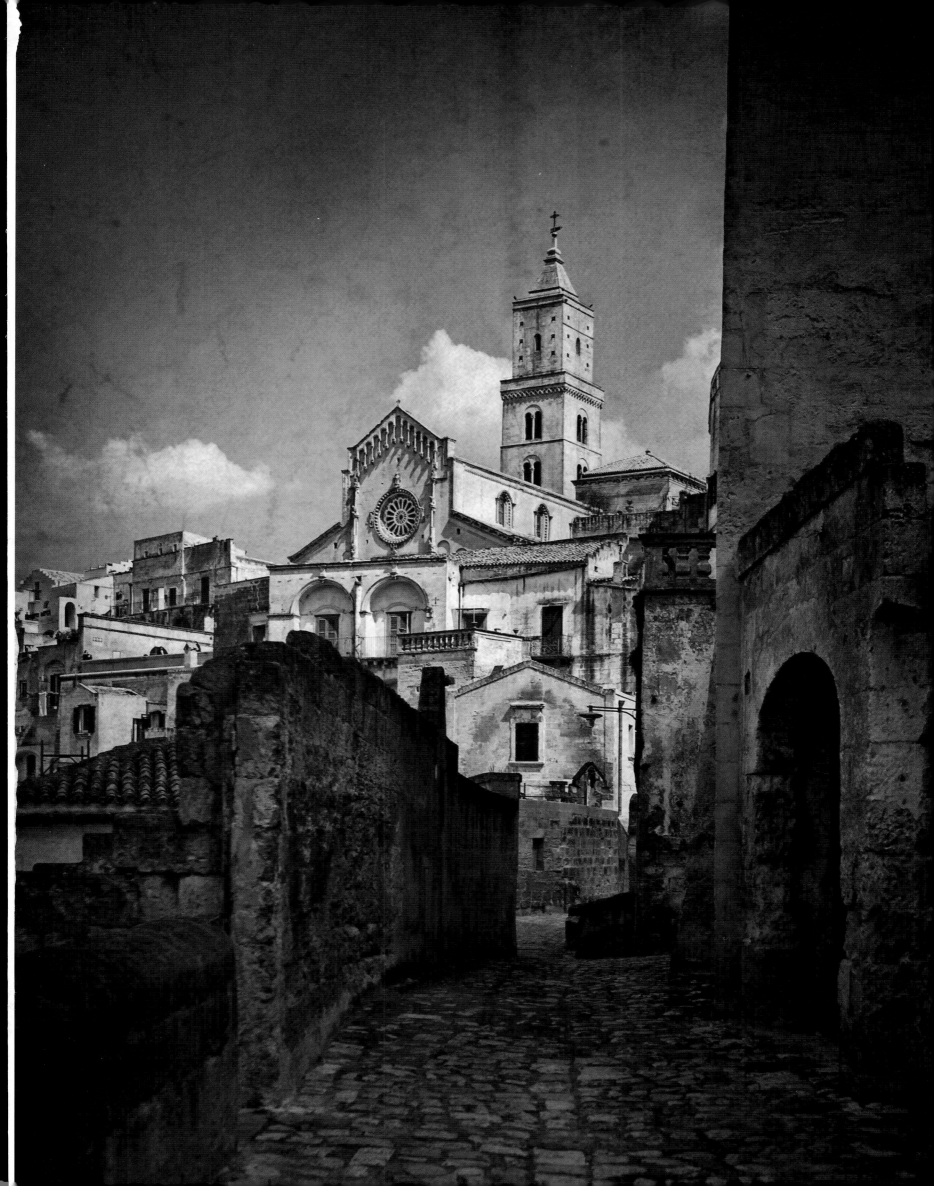

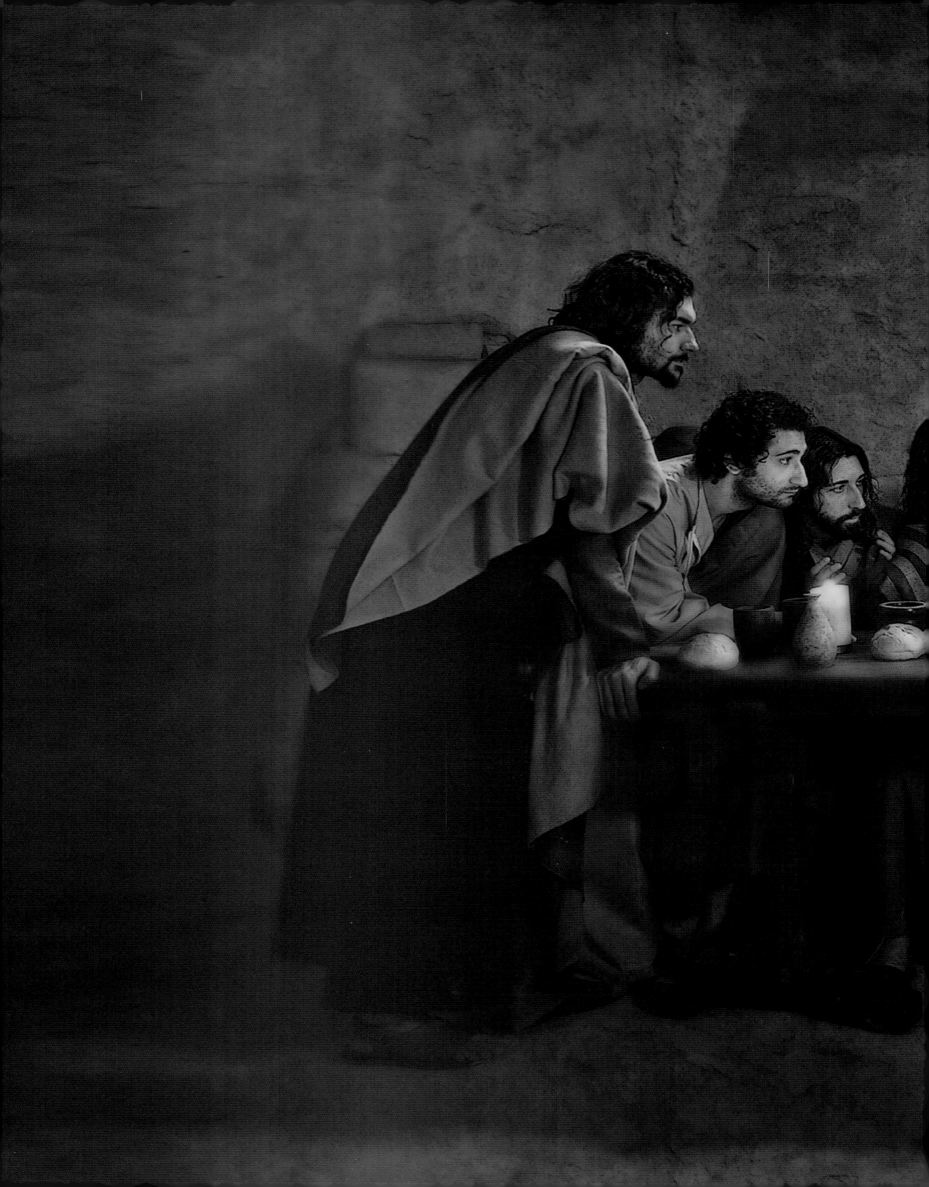

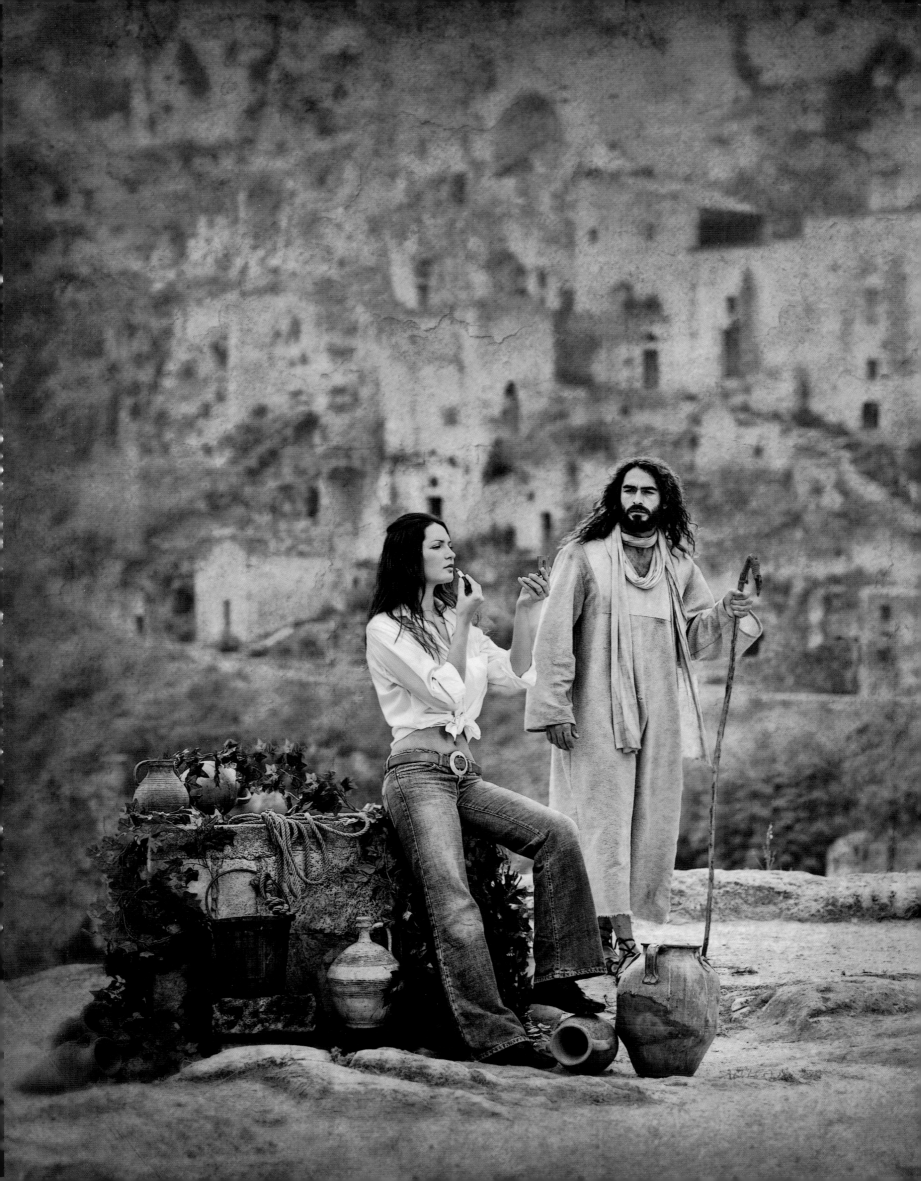

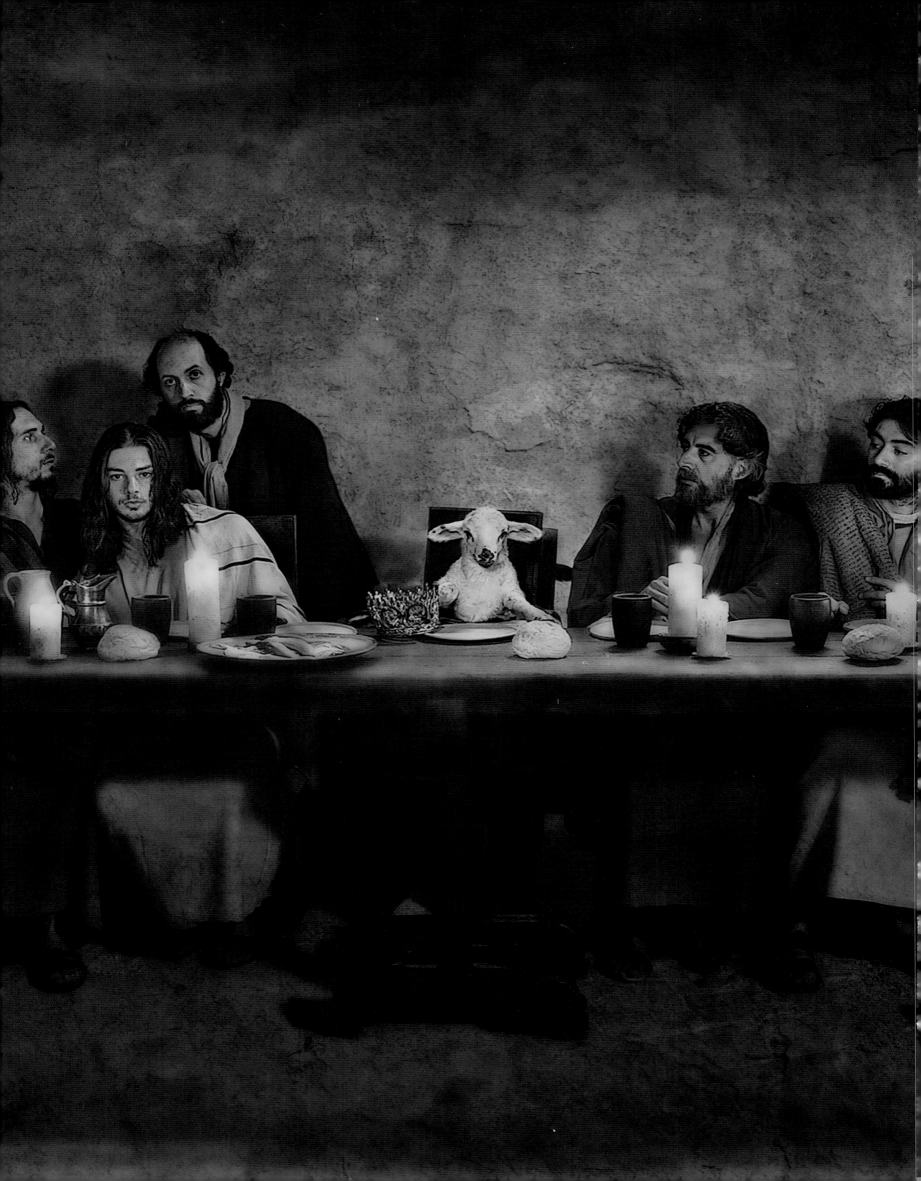

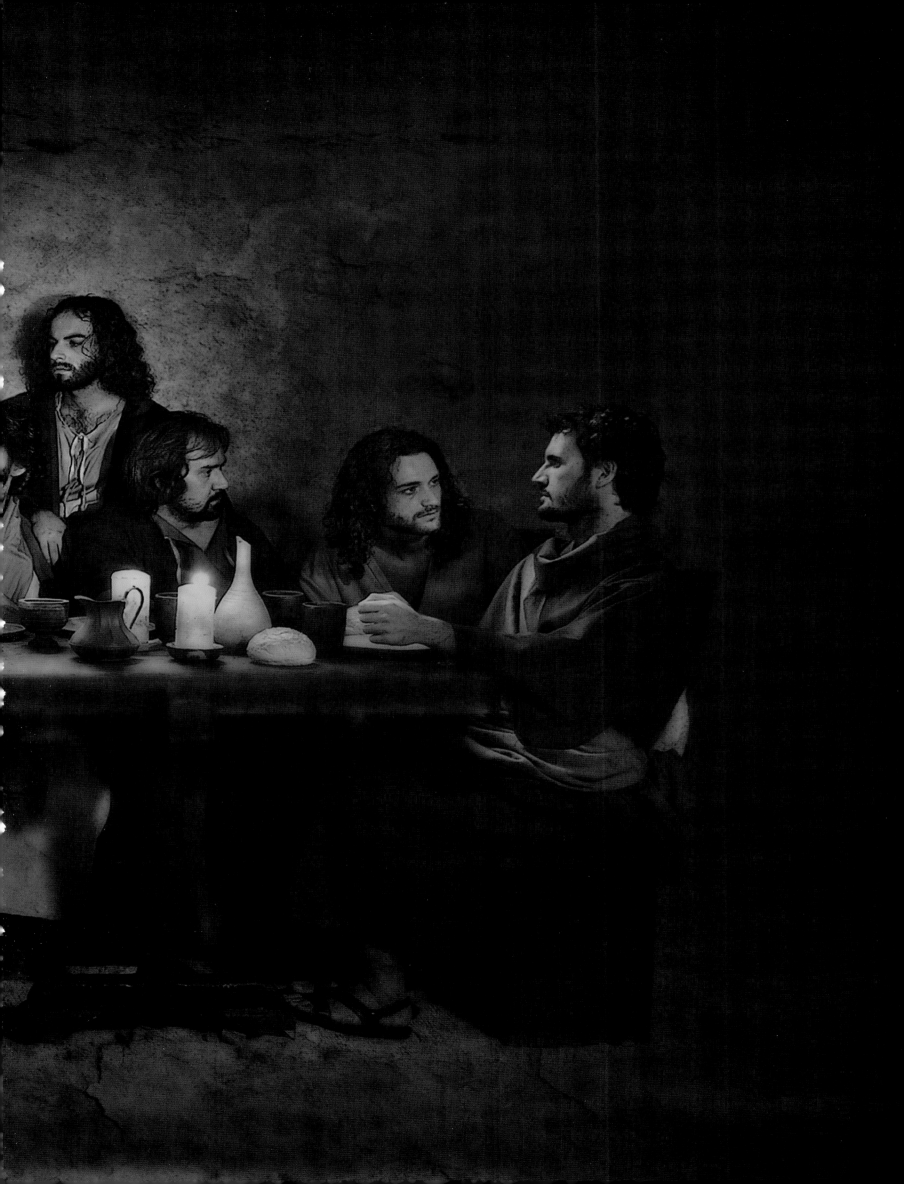

PASSOVER
The promise at the Last Supper.

*I*magine that you have been following Jesus for three years. Then, one night during dinner, He takes bread and tells you to eat it for *"this is My body."* Then He takes the wine cup and tells you to drink it, *"for this is My blood."* Such commands would be alarming and, on that night, the disciples had no clue of what He was talking about... at least until later.

The dinner was to celebrate the Passover, which got its name from when the Israelites were in captivity in Egypt and God sent plagues against the ruler, Pharaoh, in an effort to release the Israelites. The final plague would kill the firstborn sons. However, God told the Israelites to mark the doorposts of their homes with the blood of an unblemished lamb and the Angel of Death would "pass over" their homes saving the child.

On that night, Jesus was indicating to his disciples that He was now "the lamb;" that through His coming sacrificial death, "eternal death" would "pass over" all who believed in Him.

Death will pass over! Think about that the next time you share the Lord's Supper.

Matthew 26:26-29

COMPASSION

There is often more to the story than what first meets the eye.

There is a Gospel story about Jesus traveling through the region of Samaria where He encountered a woman alone at the local well. After He asked her for a drink of water, she was surprised as He revealed things He knew about her life: She had been married five times and was not married to the man with whom she was living.

Since childhood, I have heard and read the story of "The Woman at the Well" many times. Her circumstances just lead me to assume that she was a prostitute. As it turns out, I may have judged her without knowing all the facts.

One scholar of 1st Century Judea suggests that it would be unlikely that she was a prostitute and more likely that she was barren and could not have children. This may explain why she had been married so many times. She would get married, could not bear children and the husband would divorce her.

Thus, she went to the well alone because of the stigma this placed on her. People may have gossiped and could have been so callous as to tell her she was "not in favor with God."

Fortunately, Jesus did not see her as we do. He saw her as a woman scarred by her past, a woman who had lost hope. Thus, He approached her with compassion rather than contempt and condemnation.

This is a story that sets an example for all of us: We are not to gossip about or judge others. Chances are, we simply do not know all the facts!

John 4:4–26

AS FOR OTHERS
Our beliefs are best illustrated through our actions.

*J*ust saying that "I believe" something is a world apart from actually living out my beliefs with my actions.

While teaching His disciples, Jesus confused them when He said, *"Just as you gave Me food when I was hungry and visited Me when I was in prison, so you have done the same for others."* Knowing they had not done such things, His disciples asked, "When did we do this?"

Jesus' reply sets the example of how we are to live for others. *"Just as you did these things for others, it is as if you have done them for Me."* His message can be summarized in two simple phrases: *"Love God. Love your neighbor."* And, He said they were *"alike."* In other words, you cannot do one without doing the other.

So, just saying, "I believe in human rights" or "justice for all" or "I am a Christian," is altogether different than actually backing those beliefs with actions. Jesus' message to His disciples, and to us, is that we need to "walk the talk."

Matthew 25:35-40

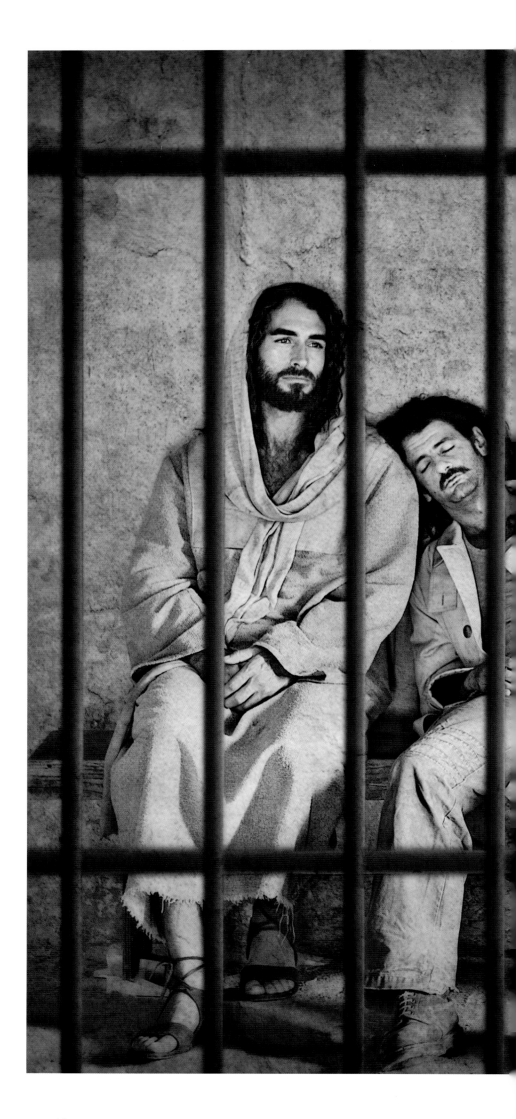

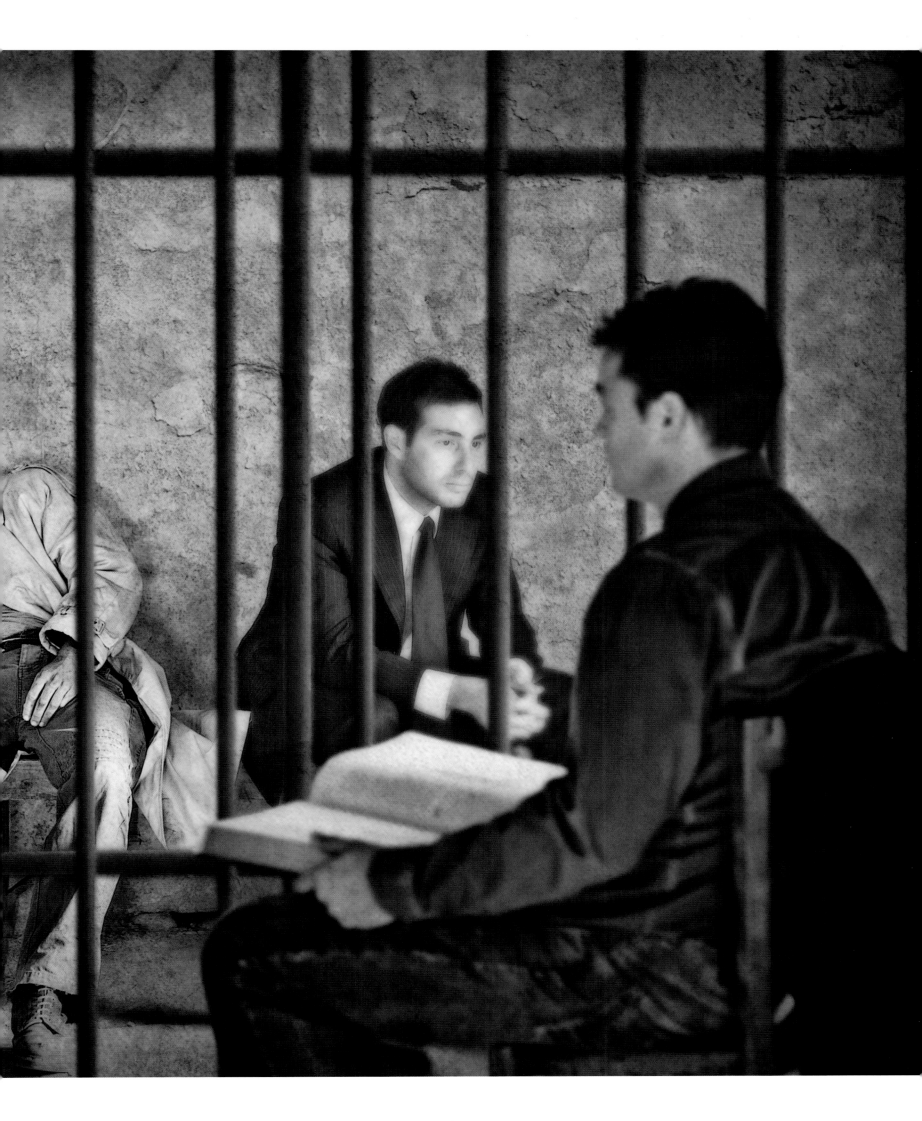

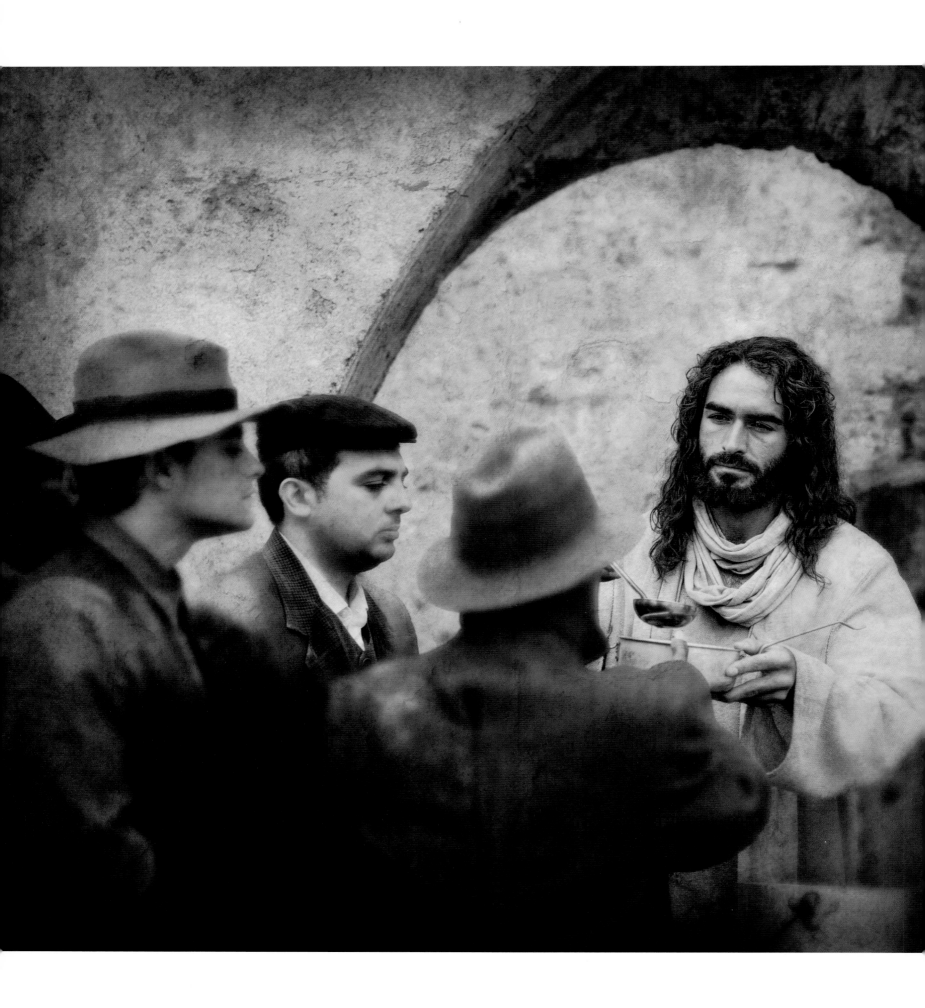

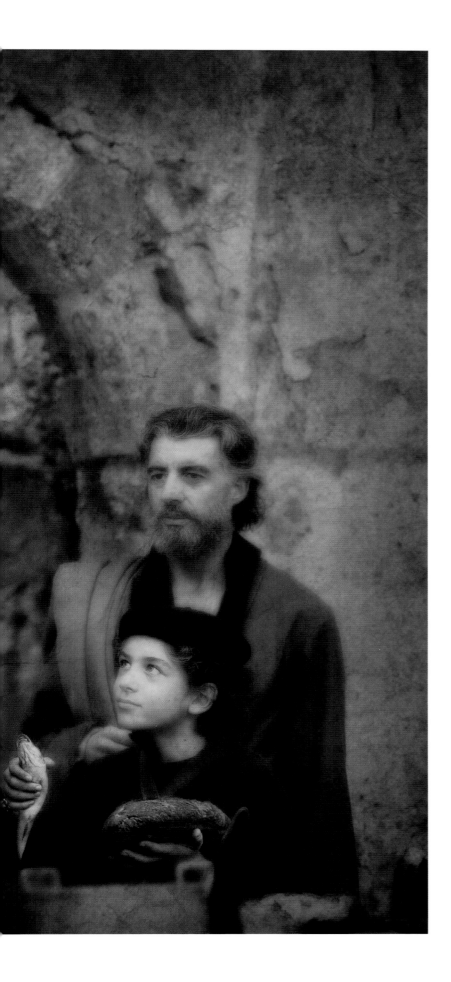

YOU FEED THEM

Jesus' unique plan for feeding the world.

*O*n two occasions, Jesus performed miracles when He fed thousands of people with only a few loaves of bread and a few fish. Leading up to one of these miracles, His disciples came to Him suggesting that the crowds be sent away to find food and lodging.

Instead of sending them away, Jesus responded to the disciples with a message that echoes throughout the world today, *"You feed them."*

Caught off guard by Jesus response, the disciples answered by saying, "But we have only five loaves of bread and two fish"…to that, most of us can add, nice homes, savings accounts and well-stocked pantries…"or", as the disciples continued, "are you expecting us to go buy enough food for this whole crowd."

Jesus' answer to them, and likewise His answer to us, was simple, but adamant, *"Yes, you feed them."* What a wonderful plan for feeding the hungry. He expects nothing less.

Matthew 14:15-18

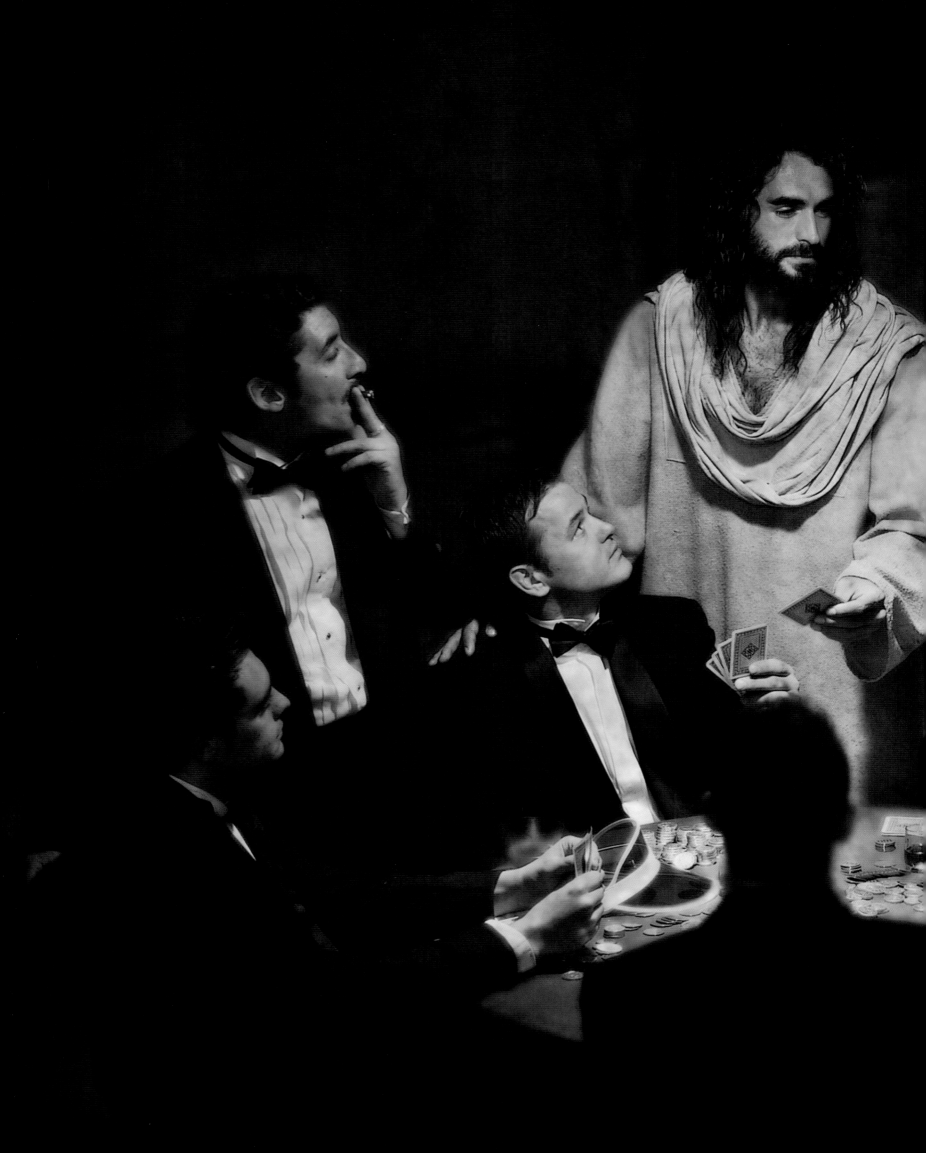

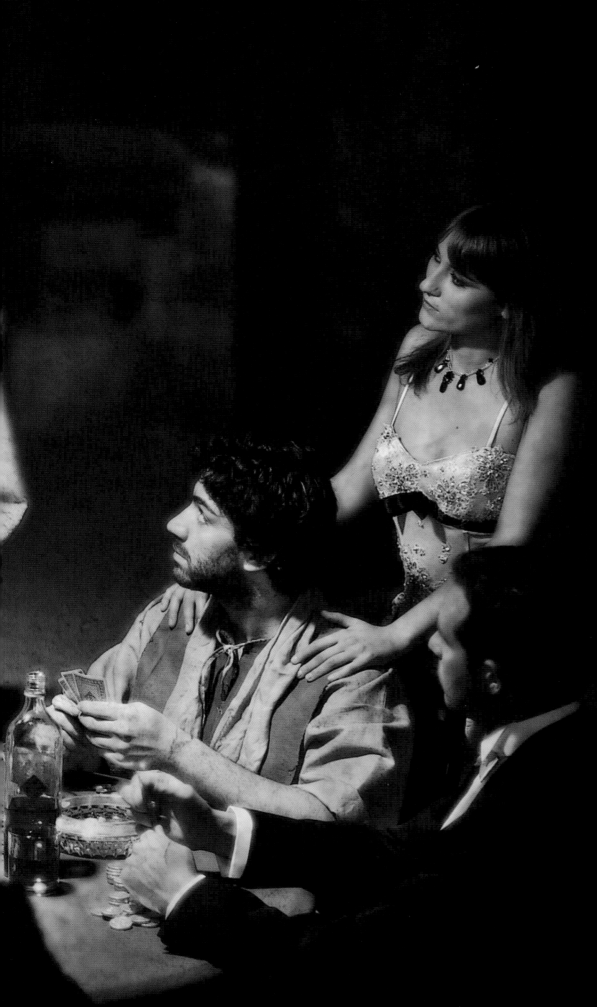

THE WINNING HAND

Trusting Him with the good hands and the bad.

There are times when our lives unfold like a game of cards. We all want the winning hand, but the odds say we will not always get it. For some, this is frustrating. And, like in the game of poker, we try to make other players believe we have something we don't. That is when "gambling" begins. Even with discipline and an understanding of risk versus reward, we can only win for awhile before the odds beat us. God wants us to understand that, although we do not control how the cards are dealt, we can choose to enjoy the game. He wants us to take each hand we are dealt…the good ones and the bad ones…and rely on Him to show us how to play them. Life is not about winning, but about the journey. Without Him, we might as well fold.

Jeremiah 29:11

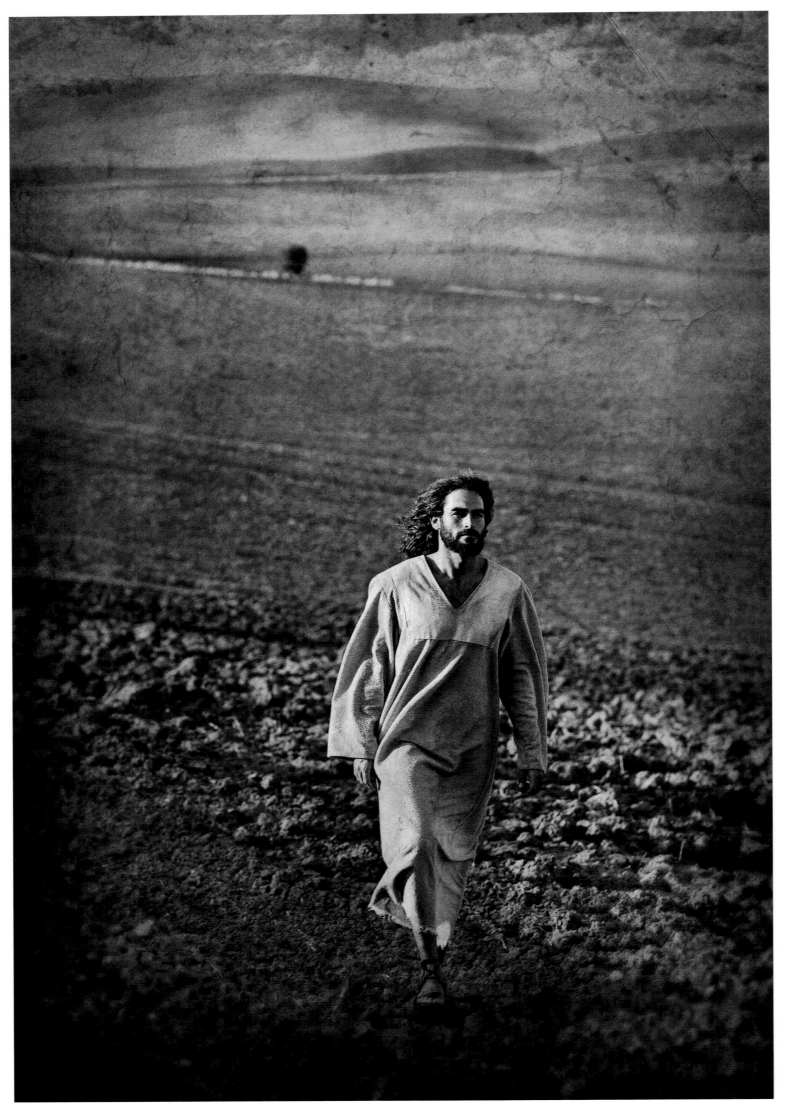

Messiah IX

Jesus was a traveling man, constantly on the move from village to village as He shared the messages of The Kingdom of God and the truth of His Father.

Every life is a journey, but they are not always in the direction that we first set out. The winds of change often send us on unexpected detours. However, when the winds subside, we can get back on course as long as we remain aware of our ultimate destination.

What course direction have you set? Is your compass pointed toward Heaven? Why not make that your final destination, while enjoying your journey on Earth?

THE ROAD LESS TRAVELED
The cost of following Christ.

*A*ll too often, our fast-paced world chooses to overlook the concept that, "anything worth having requires sacrifice at some level." We are the "instant gratification" generation and the idea of "pain for gain" does not sit well with us. So, for many, "the rewards of Heaven" need to be offered at a comfortable price.

Yet, the Gospels offer no room for such negotiation. Jesus did not mix words when He told His disciples, *"If anyone would come after me, he must deny himself and take up his cross and follow me."* Jesus tells us that there is a *"cost of following"* and He talks about a *"broad road, a narrow gate,"* and having to *"endure to the end."* He even warns us that we had better *"count these costs"* before we decide to saddle up with Him. "That's a lot to ask," we might say. "What's the upside?"

"I came that (you) may have life, and have it abundantly." In other words, "the abundant life" is the reward. Jesus tells us that the fullest life comes when we put others' needs before our own; that true joy, love, peace - and Him - are found at the back of the line rather than the front and that the "rewards of Heaven" await us on this unconventional "road less traveled."

Matthew 16:24

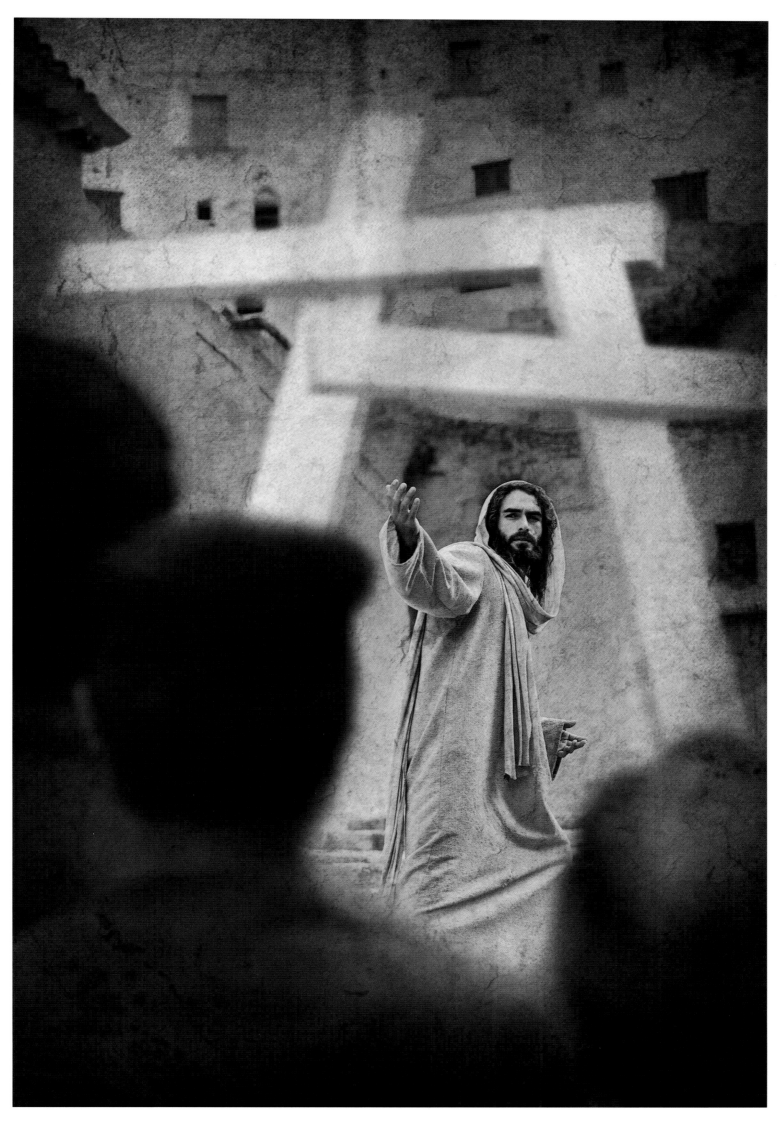

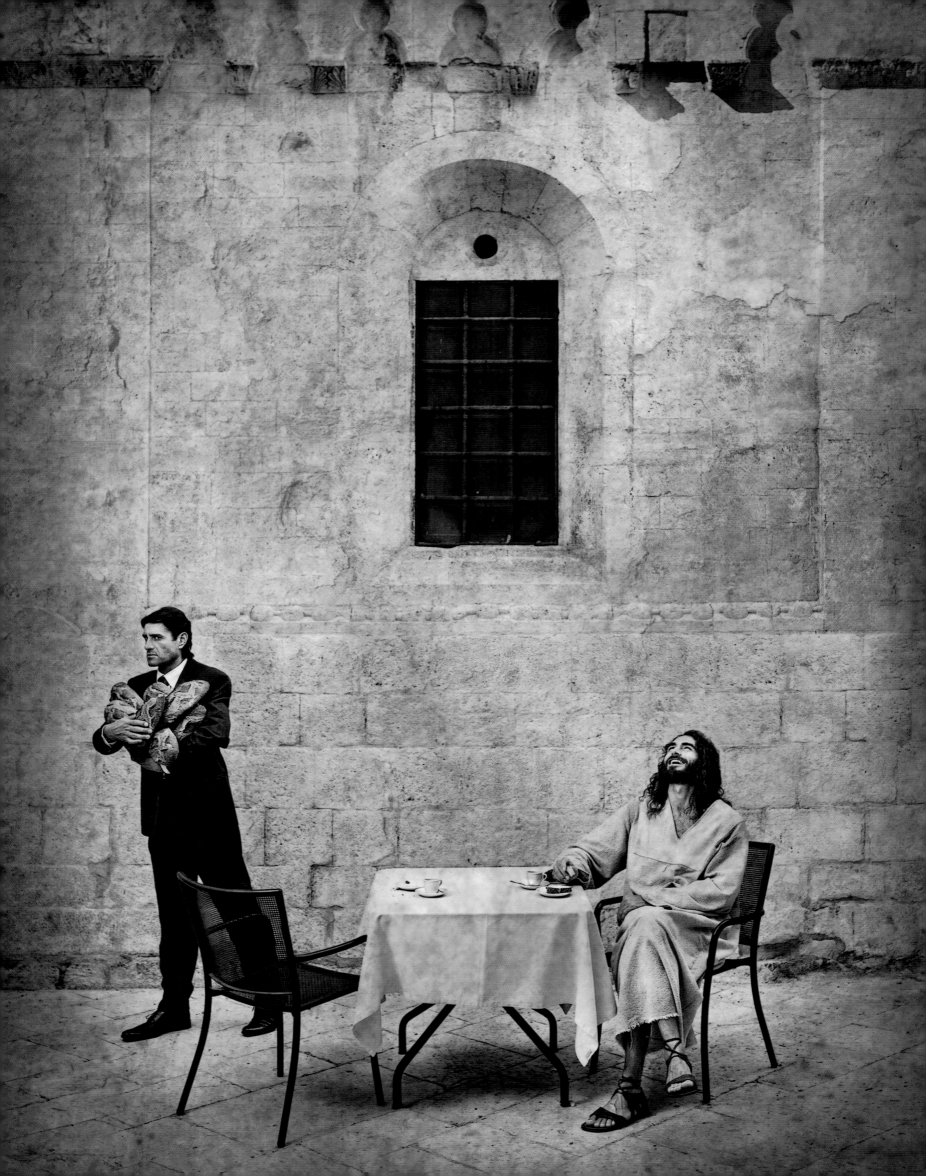

DAILY BREAD
Living today. Secure in tomorrow.

*A*s the stock markets crashed in the fall of 2008, I panicked as I saw my life savings evaporate before my eyes. Almost half of everything I had counted on for the future was gone.

In the days just before this catastrophic financial collapse began, I studied the scripture that we now refer to as The Lord's Prayer. Of the six sections of the prayer – the first three to the honor of God and the second three for the needs of man – the fourth part is *"Give us day by day the bread we need."*

It dawned on me that, despite the promises Jesus has made about God taking care of my needs, I do not trust Him for those needs on a day-by-day basis. Not only do I want my bread today, I want to know that I have tomorrow's bread, today. And, I want to know that I have my "retirement bread" and lots of it!

Jesus tells us that worrying about tomorrow takes us away from today. He wants us to live now, in the present, in this moment, because it is the only place He can meet us to meet our needs. He cannot meet us in tomorrow, because tomorrow does not exist...and may not.

Life can, and will, be peaceful today when we surrender ourselves to His promise and stop worrying about tomorrow's bread.

Matthew 6:11

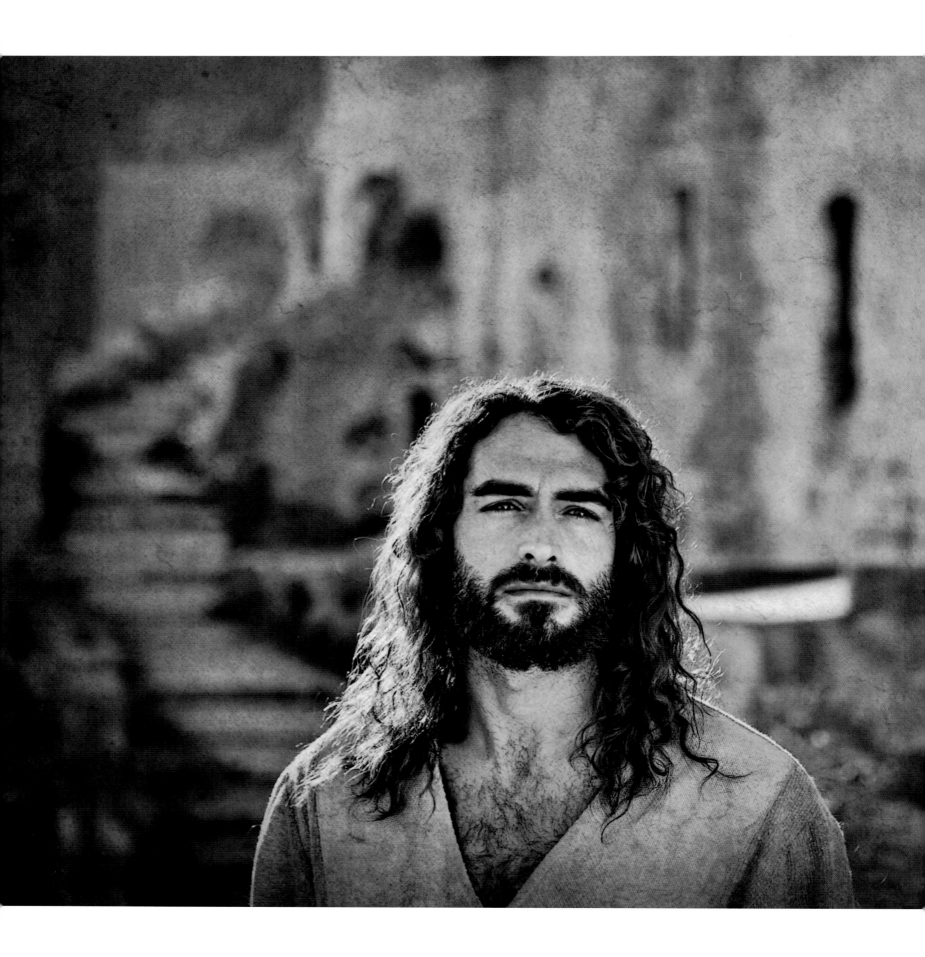

MESSIAH V

From time to time, as we travel the roadways of this journey we call life, we arrive at crossroads. Some are detours, while others are temporary road blocks. Yet, rarely do we come to the end of the road. What first appear to be obstacles in our path, often turn out, upon closer examination, to simply be choices we must make. Choose the path to the right, and you miss out on the pathway to the left. It's okay. We cannot travel both roads at once.

Invite Jesus along on your journey. Then, even when you are temporarily heading down the wrong road, He will open your eyes to the dangers ahead, allowing you to backtrack to the intersection where He can help you make a better choice.

R.S.V.P.

A lesson in spiritual etiquette.

While dining at the home of a prominent Pharisee, Jesus told a parable about a man who planned a great banquet and invited many guests. When it came time for the party, the invited guests sent "regrets," offering pathetic excuses as to why they could not attend.

This made the host angry. So, he sent his servants out to invite everyone…the poor, the blind, the lame…saying that "none of those who were invited will ever taste my great feast."

Jesus is making a point to which we must all pay attention. He has invited us to the greatest party that will ever be given…a life in Eternity with Him. Some have replied with a resounding, "Yes, I cannot wait to attend." But, there will be many who are simply, and foolishly, too busy with their earthly lives to accept his invitation.

Make sure that you have sent a R.S.V.P to His invitation. This is a party you and your loved ones will not want to miss.

Luke 14:16-23

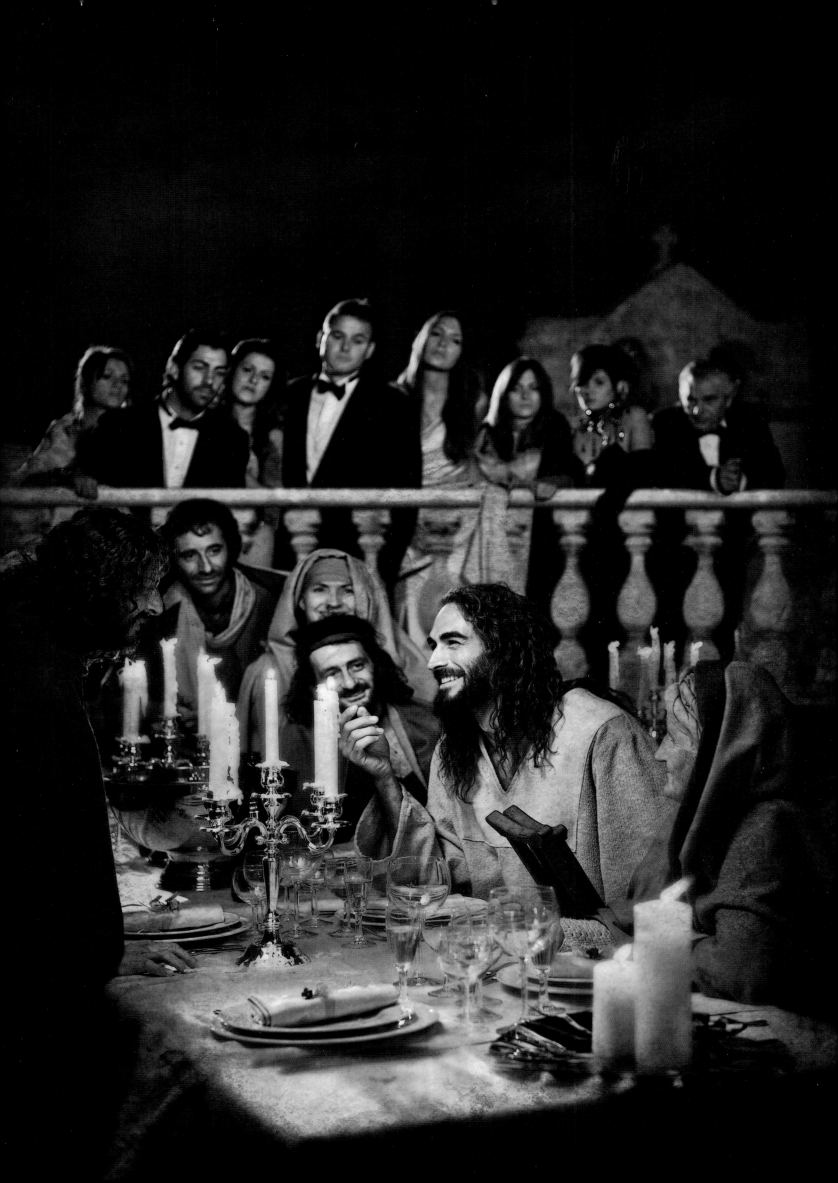

DENIAL
If only three were the limit!

It is one of the most familiar stories of the Gospels: boisterous Peter telling Jesus he would not stumble as a disciple and confidently stating, "Even if I have to die with You, I will not deny You."

Oh, if we had such strength!

Jesus, however, warned Peter that he would, in fact, stumble by denying Him – three times to be exact – and this would happen before the rooster crowed. As predicted, after Jesus was arrested on the night before His death, He listened while, three times, Peter denied that he even knew Him.

It is human nature to commit to more than we can handle. We all fall short on some promises. Yet, when we stray from God's path by acting in any way that is not "Christian," are we in a sense like Peter, denying that we know Him?

Peter had another chance, an opportunity to redeem himself, and was eventually crucified upside down rather than deny his Savior again.

Luke 22:33-34, 54-62

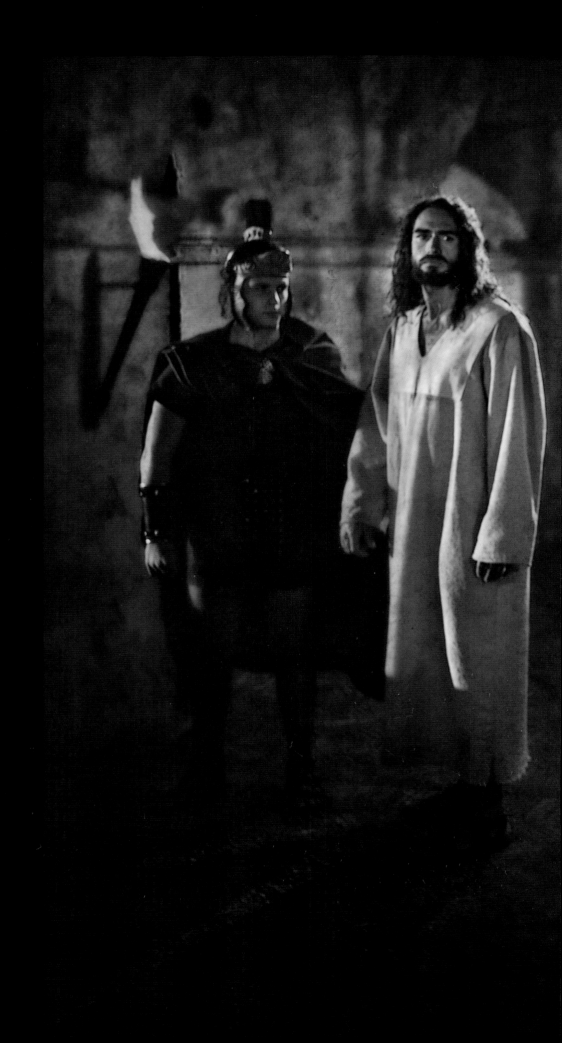

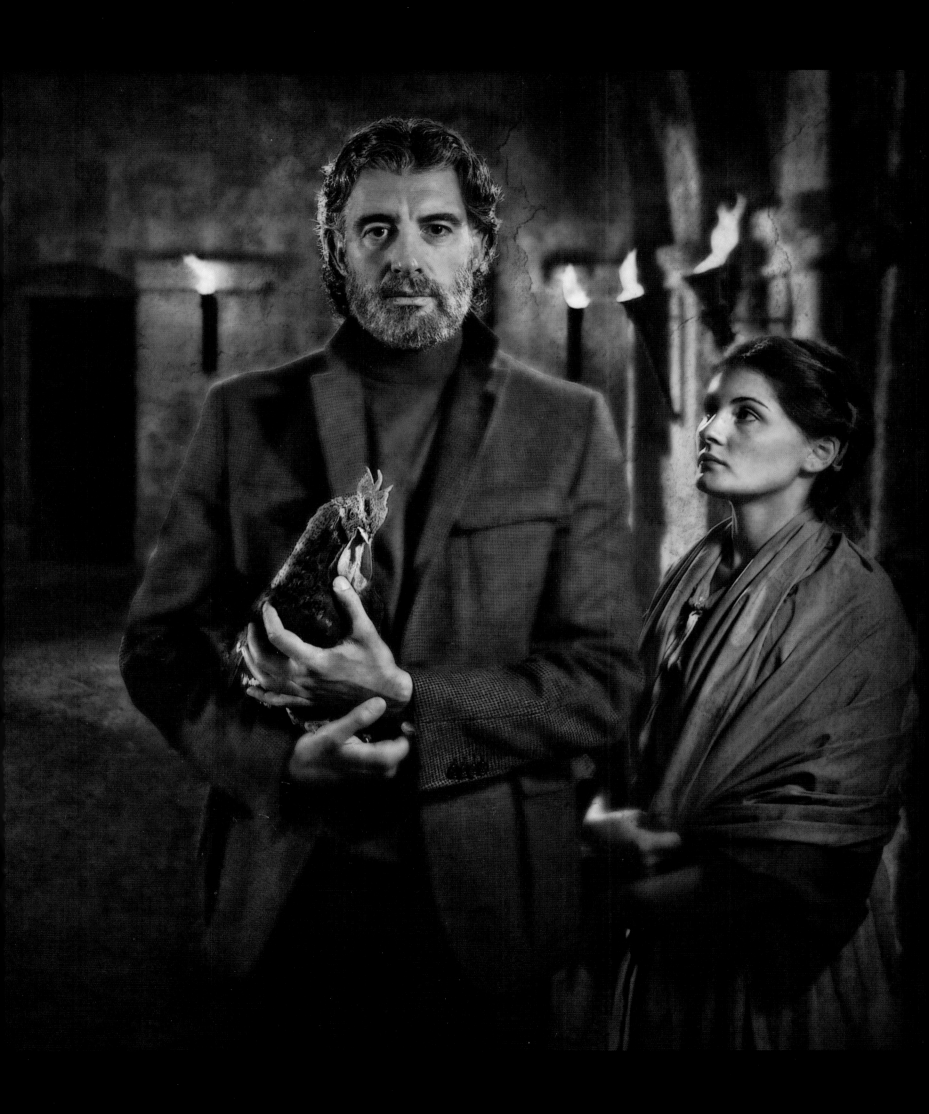

Messiah II

When asked by the Pharisees, "What is the greatest commandment?" Jesus answered, *"Love the Lord your God with all your heart and with all your soul and with all your mind. This is the first and greatest commandment. And the second is like it: Love your neighbor as yourself."* Yet, you will not find those commandments directly stated within the Ten Commandments!

You see, of the Ten Commandments, the first four tell us how to love God and the second six, how to love our neighbor. So, when asked, Jesus simply summed up the first four Commandments and the second six.

This is God's message to us from the beginning of time and the truth that He sent His Son to share: "Love God. Love your neighbor." They are really one in the same.

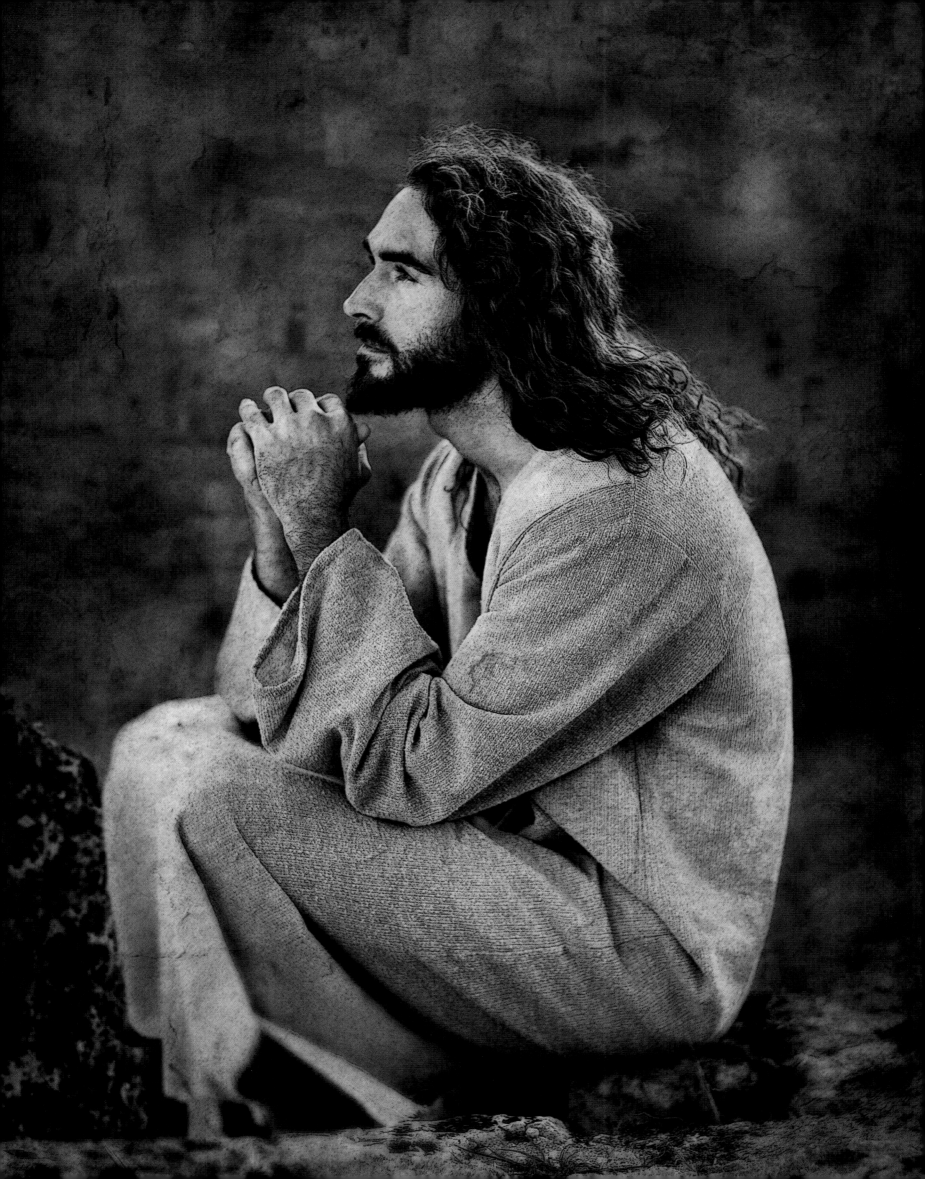

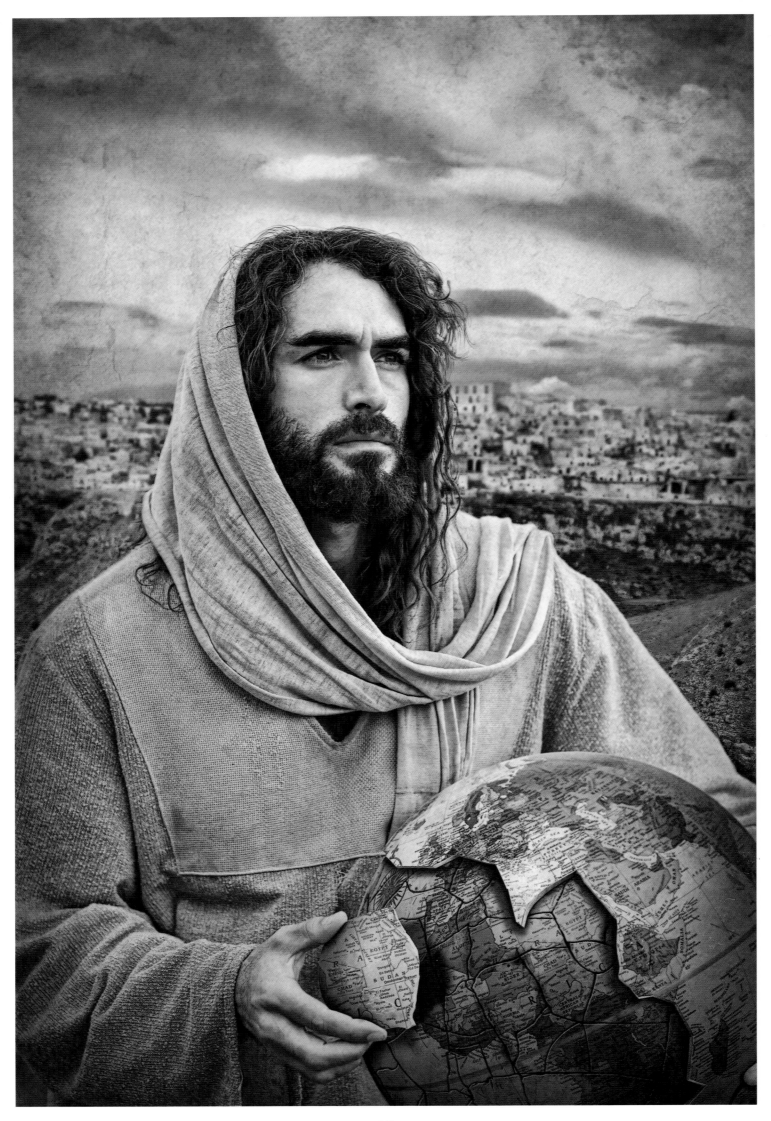

THE PROMISE

Will God throw away His magnificent creation?

On five occasions, while creating the heavens and the earth, God stepped back to admire his work and announced that His creation was "good." Although we have not cared for "our home" as we should, abusing it and ourselves in so many respects, why would we believe that God will just throw away His magnificent creation?

In the Book of Revelation, Jesus references a New Heaven and a New Earth and then declares, *"Behold, I make all things new."*

What a promise! *"All things new."* Surely that means that the difficult times we experience now are only temporary and that the New Heaven and Earth will offer a far more substantial world; one that offers the hope of perfect health instead of sickness and death; a world that offers pleasure, peace and joy instead of sadness, war, violence and adversity.

Without the hope of a New Heaven and New Earth, there really is no hope at all.

"All things new." It is His promise.

Revelation 21:5

WATCH YOUR STEP
Avoiding religious ditches.

By the time Jesus began His ministry in the early days of the 1st Century, the Pharisees (the religious elite of that time) had added many of their own rules to the Jewish laws. There were so many "do's" and "don'ts" that religious life had become a burden to the Jewish people.

There are many in our religious communities, like the Pharisees of old, who have allowed the "purpose" - the intended message of Jesus - to be overshadowed by the "process" of trying to act religious. Jesus referred to these people as the *"blind leading the blind"* and said that this type of misguidedness would eventually lead them to *"fall into a ditch."*

In all aspects of life, but especially in knowing the truth of God, it is our responsibility to stay true to His word. We must sift through the religious practices that may be leading us into a ditch and away from focusing on a true relationship with Christ.

After all, Jesus did not come to start a religion. He came to testify to the truth of God; offering us a revolutionary new way of living out God's plan.

Matthew 15:14

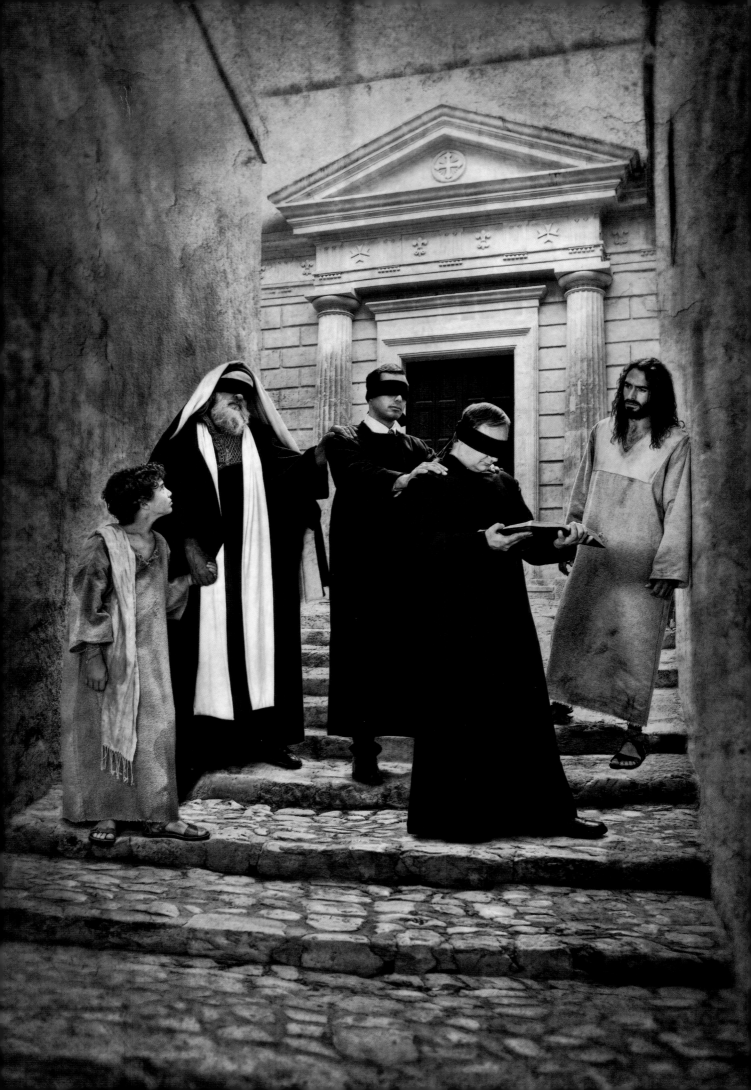

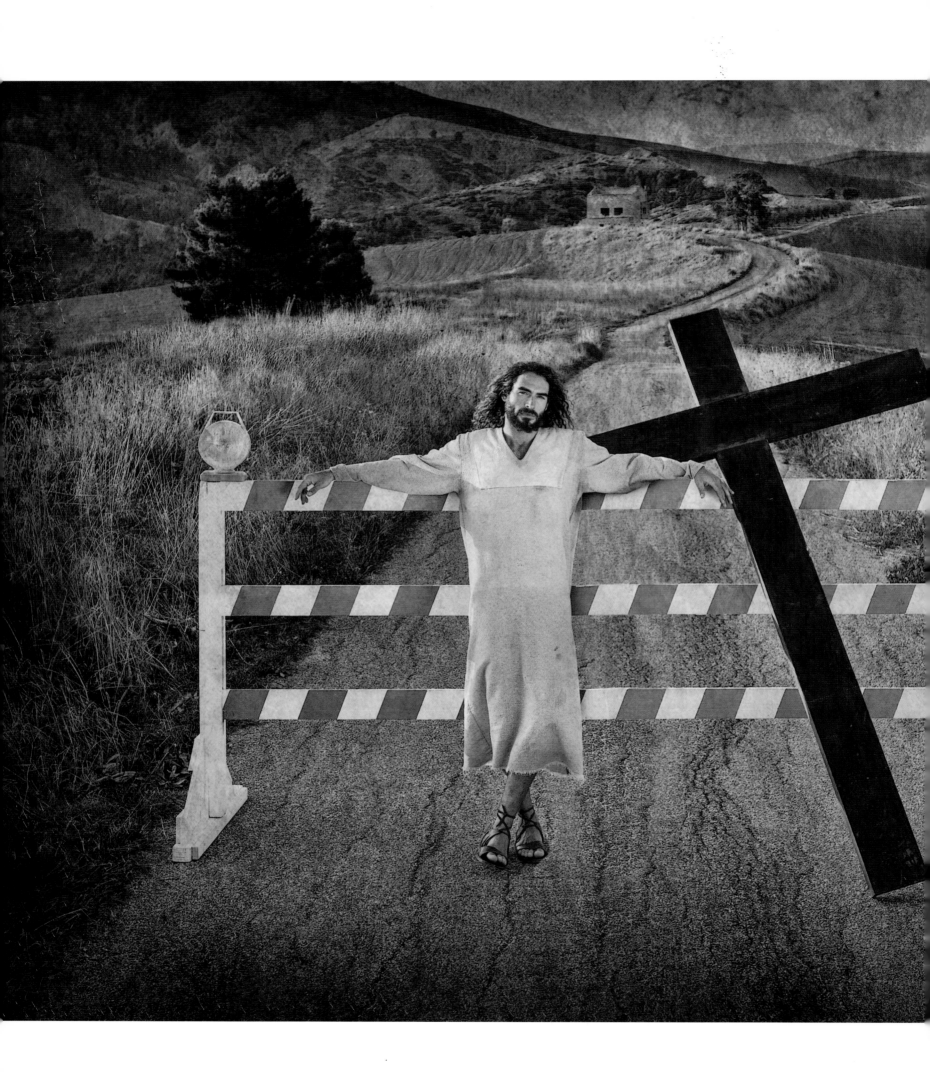

END OF THE ROAD
The future looks bright ahead.

Many of us have heard about this beautiful place called "Heaven," but what do we really know? The Bible offers solid answers, painting a picture of life in Eternity. And, contrary to many artists' depictions, it does not include sitting on clouds playing harps!

In a nutshell, the Biblical evidence points to an eternal life much like the physical ones we live now. In the "heaven life," the trials and tribulations that cause fear, jealousy, hatred, sickness and death are replaced with love, joy, peace and abundance. A world is revealed where one works because they enjoy working, but not for need of a paycheck, and a place where the lion chases the lamb, simply because they are having fun. Got the picture?

I like to think of death this way: "The end of the road is not necessarily the end of the road." We can continue down "the eternal life road" to a perfect world when we ask the Man at the roadblock to let us through. I do not recommend the detour!

John 14:2-4

Messiah VI

Although it was the most barbaric form of execution, crucifixion was not uncommon in the 1st Century, nor was it uncommon for a corpse to be wrapped and buried by placing it in a cave.

Jesus' death and burial, however, were unique beyond unique. Not only did He give advance notice of His execution, He told His disciples that His grave would be no match for Him; that He would overcome the world by overcoming death; that He would be raised to life again in a supreme example of what God has in store for us.

Thus, the resurrection validates the scriptural promise of our redemption through faith in Jesus, God's chosen one to reign. For a dead king cannot be a reigning King!

Of all the world's religions, this is a proclamation no other faith can make.

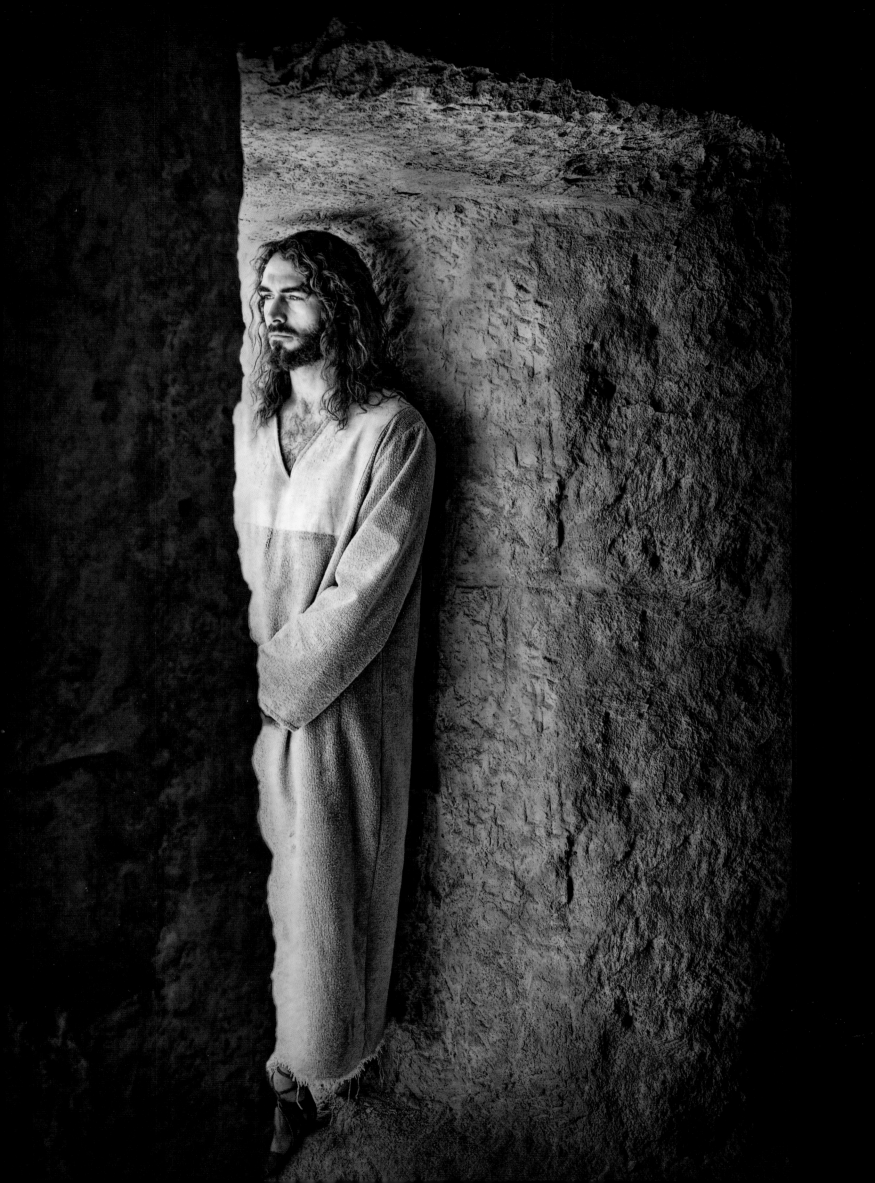

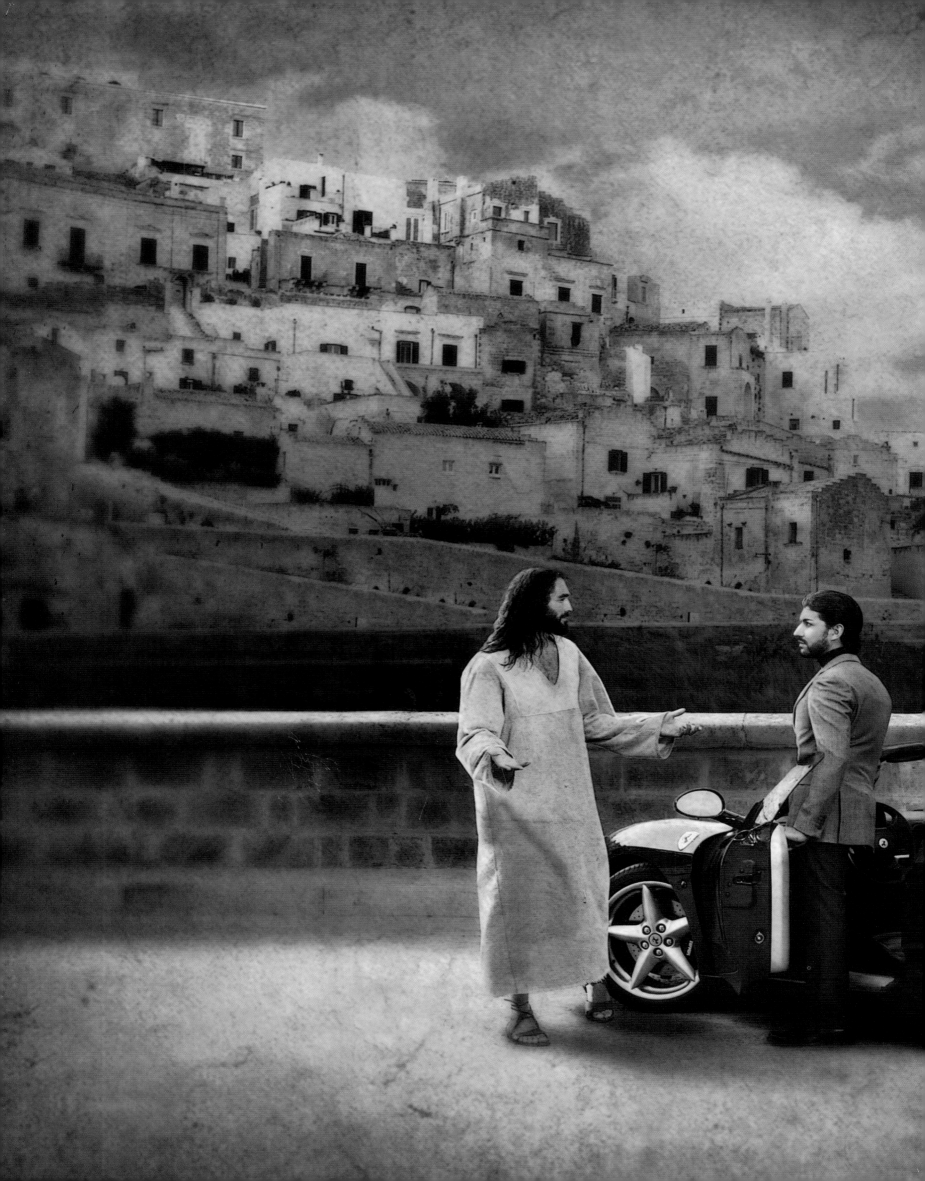

QUANDARY
The things that hold us back.

*J*esus told a story about a rich young ruler who was intrigued by Jesus' teachings and, in particular, His offer of eternal life. So, the rich young man asked, "What must I do to receive eternal life?"

Jesus responded by telling him to keep the commandments, *"Do not murder, steal or commit adultery."*

"I've got those covered," the young ruler replied. "Anything else?"

Jesus' next response challenged the young man at his very core. *"Okay, then sell all you own, give it to the poor and then come follow Me."*

Jesus does not deny us money and possessions. Yet, He knew that our attitudes about them could be the biggest stumbling block in our lives. Money issues can lead to greed, corruption, divorce, sickness, heart attacks and even suicide.

Yet, for the rich young ruler, Jesus knew that his lifestyle - money, cars and beautiful women - had become a personal road block to what he really wanted, which was to follow Jesus into eternity.

This is the quandary we all deal with from time to time. Do our lifestyles cause us to choose what is convenient and what is safe, or do we seek the road less traveled? Are the momentary comforts of money and possessions holding me back from what I really desire in life, or, even more, from the dream God has placed in my heart?

Is Jesus challenging you to follow Him on a special journey? Will you have the strength to go? Or, like the rich Young Ruler, will you just go away sad?

Matthew 19:16–26

RECONCILED

A world in desperate need of a Savior.

The Garden of Eden is a story about "choice:" Our choice to either live in eternity with God or eventually die...forever! It is a story about God's magnificent plan versus the human desire to be in control - believing we can create an even better plan.

For us, as it was for Adam and Eve, this is arrogant! It lacks in humility and it separates us - for eternity - from God, as we turn from His plan of righteous living to follow our own.

Since the gift of eternal life comes only from God, turning away from Him guarantees our eternal death.

The Old Testament tells of the sacrifices (giving up something of great value) that people offered to God in seeking forgiveness of their sins - breaking God's moral laws. Yet, we have nothing worthy of sacrifice; nothing that can pay the price for breaking His laws.

Can this ever be reconciled? Yes, but not through anything we can do on our own.

God knows we are helpless to save ourselves. And, yet, He loves us so much that, rather than see us die, He paid the price for our sins by sacrificing that which was of most value to Him - His Son, Jesus.

Wow! You've really got to love someone to give up your child for them!

Now, whoever turns back to God by accepting Jesus, not just as their Savior, but also as the Lord of their life, will be reconciled back to God to receive His gift of eternal life.

John 3:16

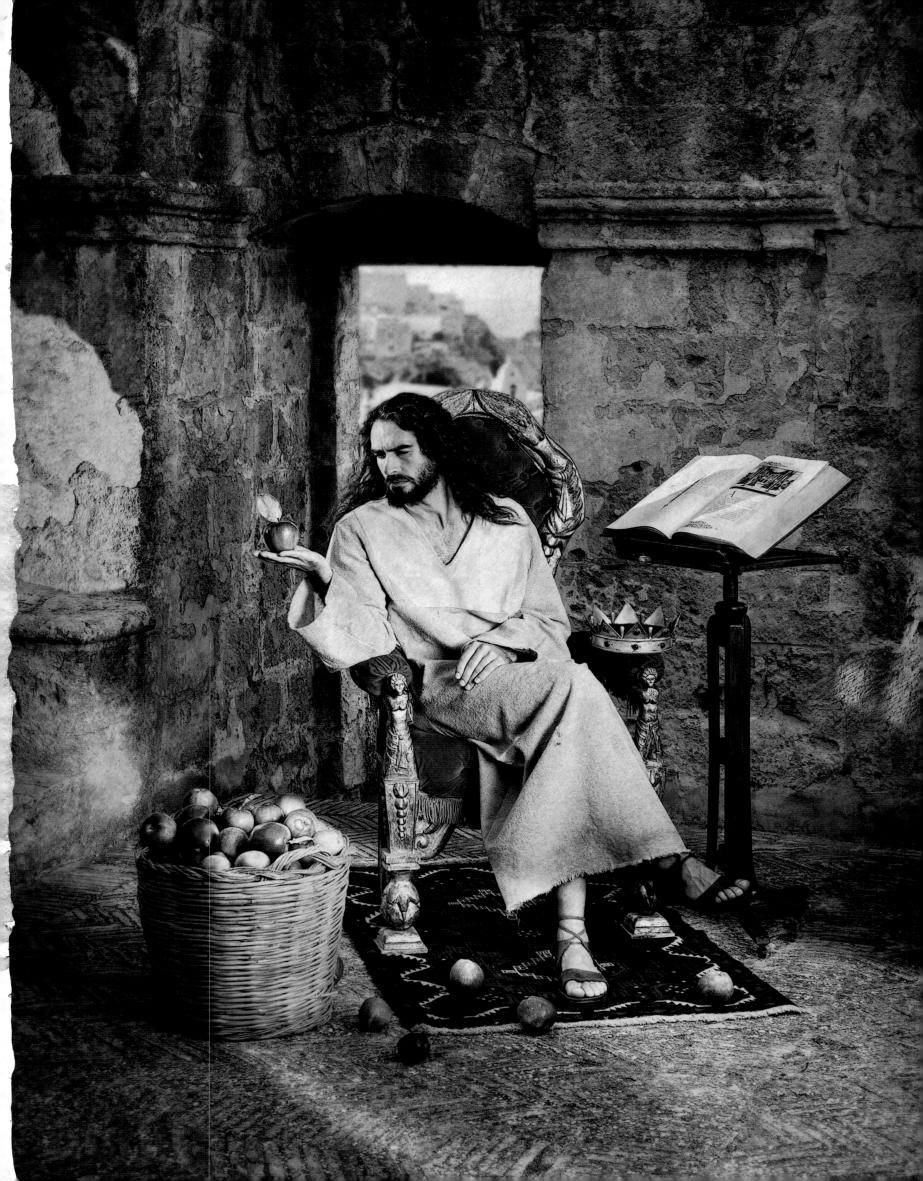

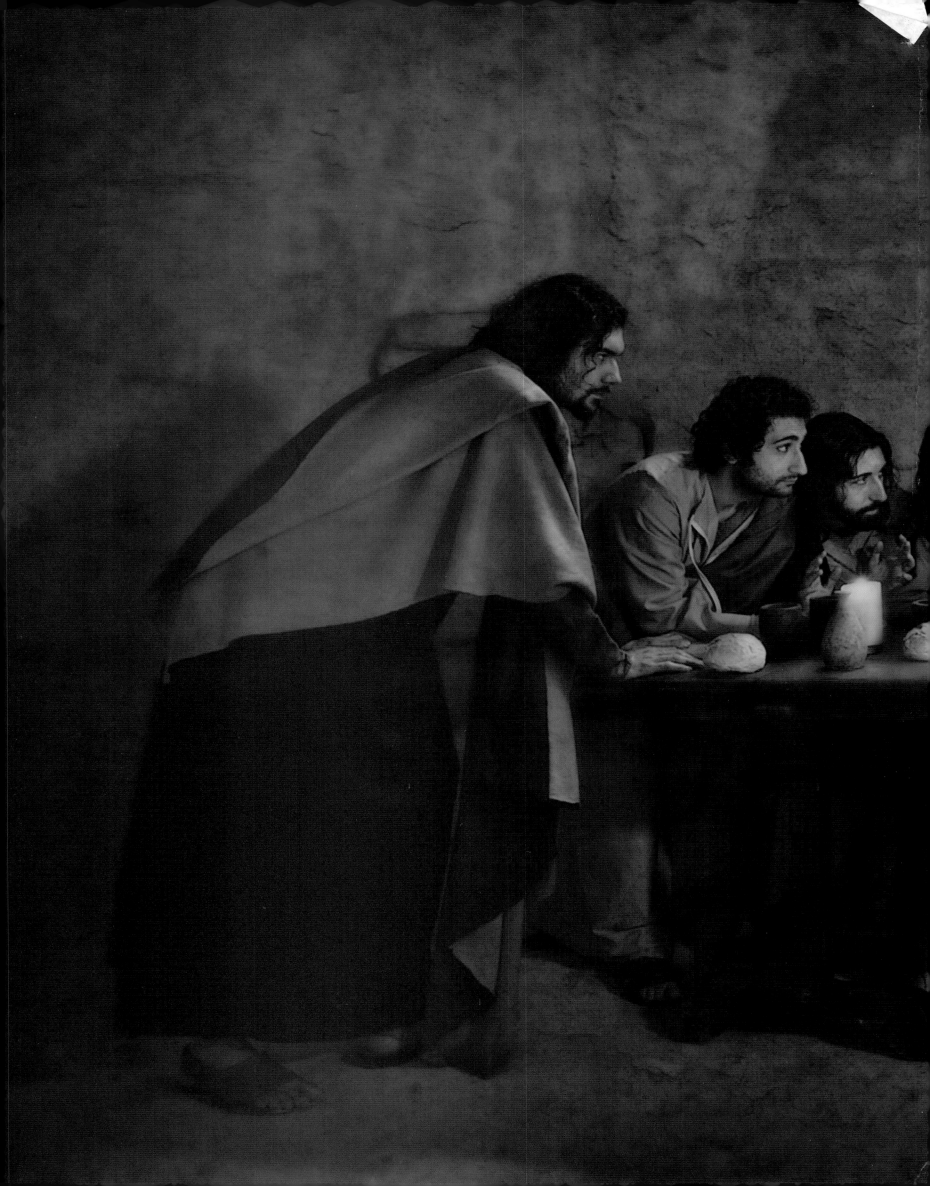

THE LAST SUPPER.
Lessons on how to be blessed.

*O*n the night before His arrest, during the Passover meal that Christians now call *"The Last Supper,"* Jesus rose from the table, poured water into a basin and got on His knees to wash the feet of His disciples. As their leader, it was an unusual gesture, perhaps like a country's President washing the feet of his Cabinet.

Upon returning to his place at the table, He said to His disciples, *"Do you know what I have done to you? You call Me Teacher and Lord...for so I am. If I then, your Lord and Teacher has washed your feet, you also ought to wash one another's feet. For I have given you an example, that you should do as I have done to you."* Then, He tells them that, if they will follow His example - an example of doing for others - <u>they</u> will be blessed.

Many Christians call Jesus *"Teacher"* and call Him *"Savior,"* yet do we allow Him to be the *"Lord"* of our life? Since so many of Jesus' teachings go contrary to our human nature - putting ourselves before others - He is saying, *"Learn from me as your Teacher. But, as your Lord, do as I tell you to do,"* affirming that we will be the ones who are blessed when we do.

John 13:12-17

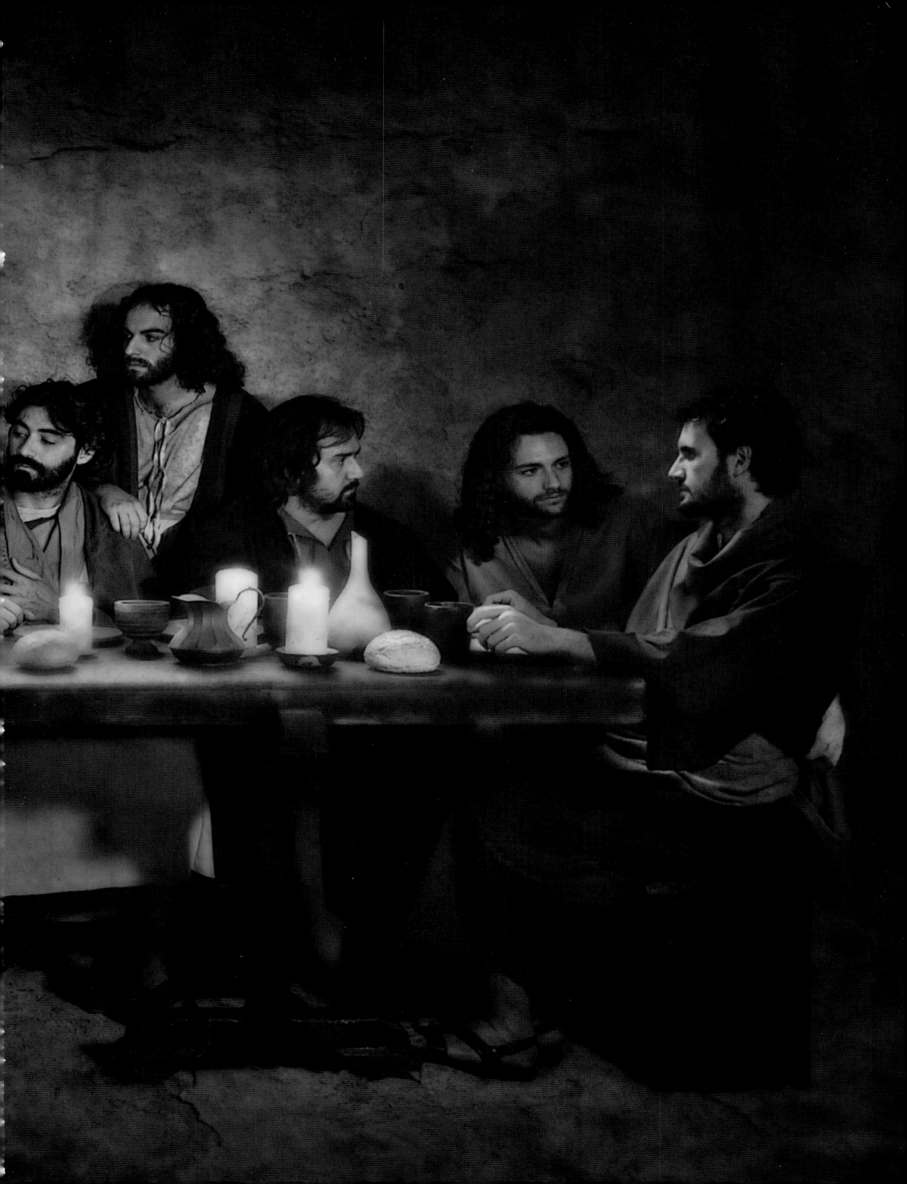

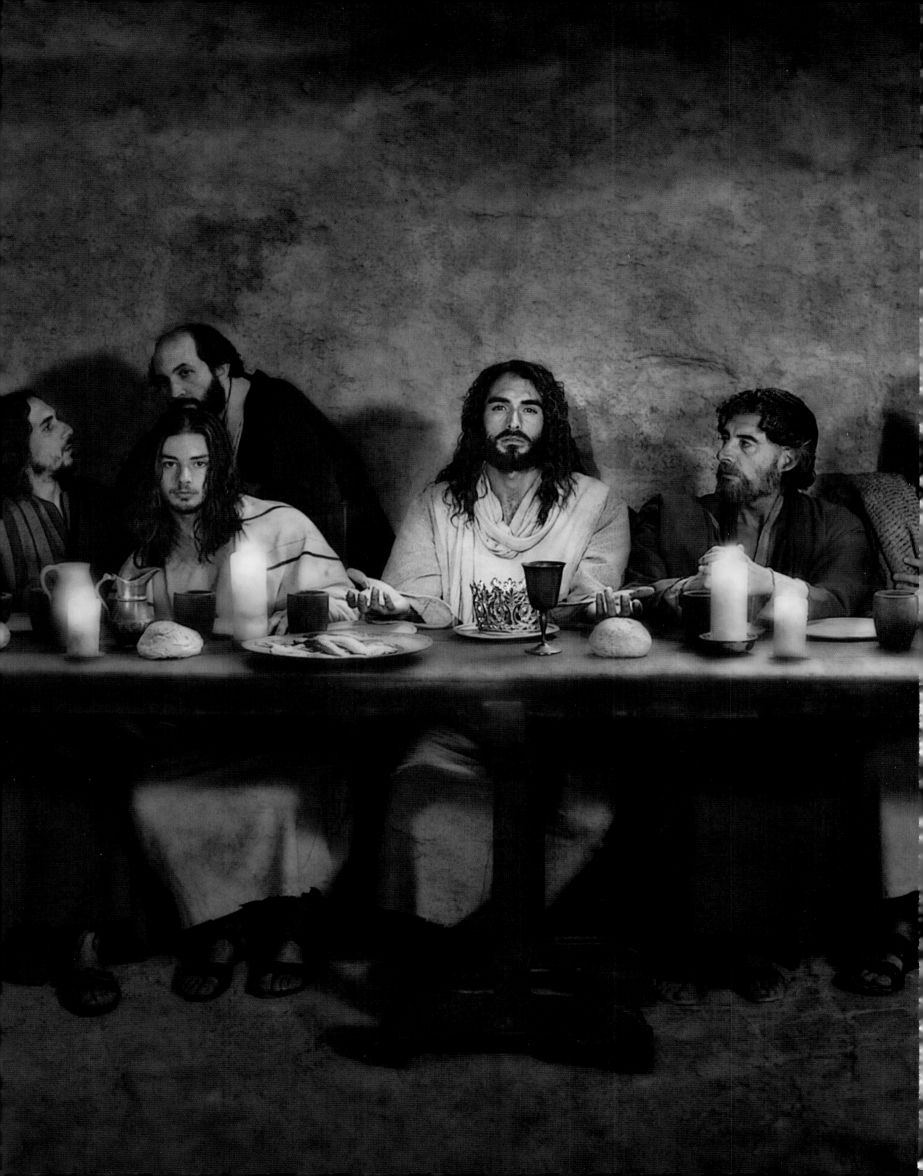

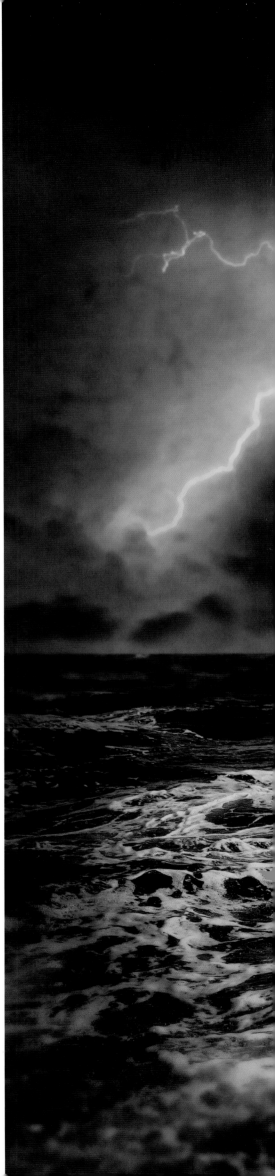

SUPERNATURAL PEACE

An antidote for whenever your world is crumbling.

The events of our lives seldom work out the way we plan. The trouble that "comes in threes" can also come in fours, fives and sixes. We learn to cope with the day-to-day troubles, but what happens when we find ourselves in a raging storm and feel we are sinking; when our child dies, our wife leaves or our job gets terminated and we have no savings to fall back on? How do we "self-service" our needs at times like these?

Jesus promised His disciples, *"Peace, not as the world gives you, but My peace I give to you."* Jesus offers us a supernatural calm, a genuine peace, in the very wildest circumstances of our lives; a peace the world cannot give and one we cannot provide for ourselves.

The next time you find yourself in stormy seas, turn to Him for this supernatural gift. He will carry you through.

John 14:27

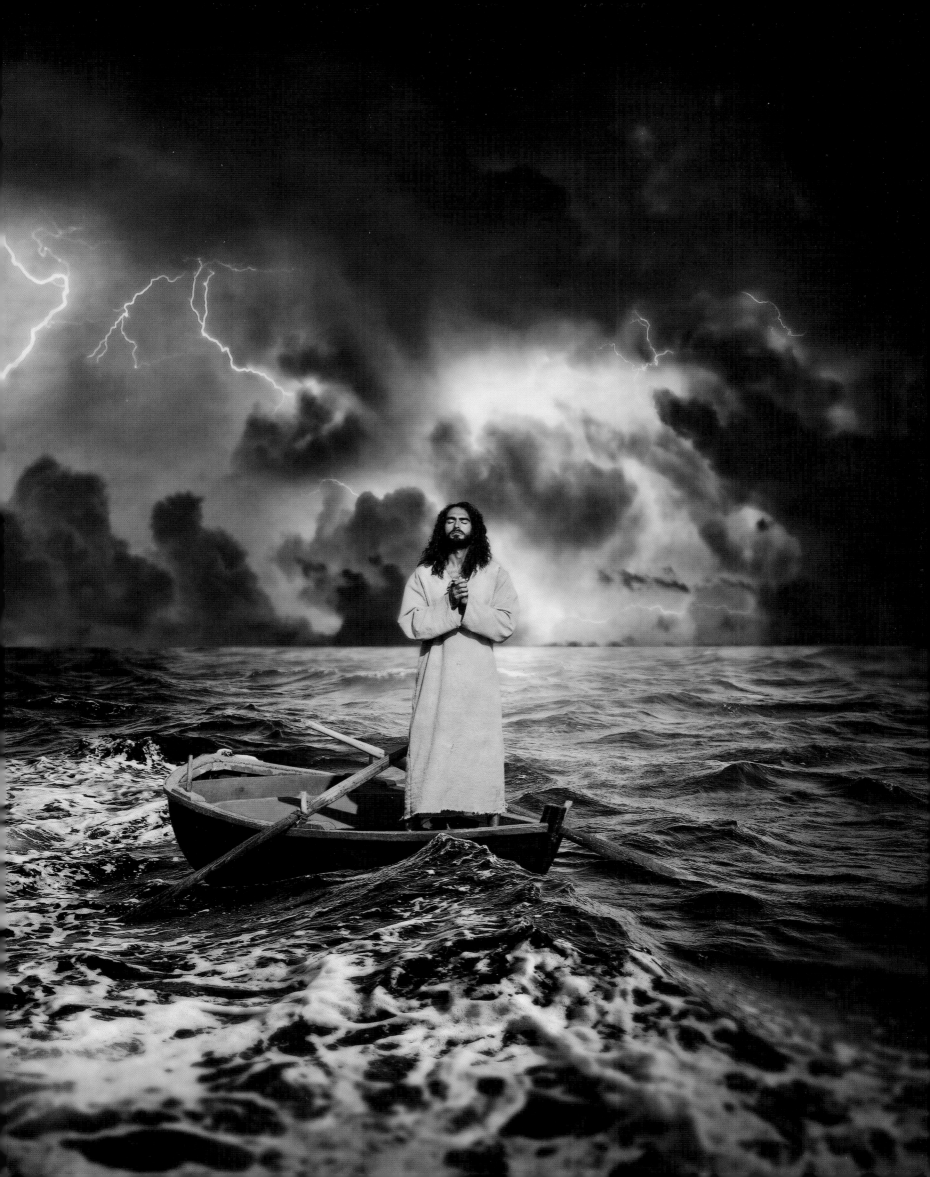

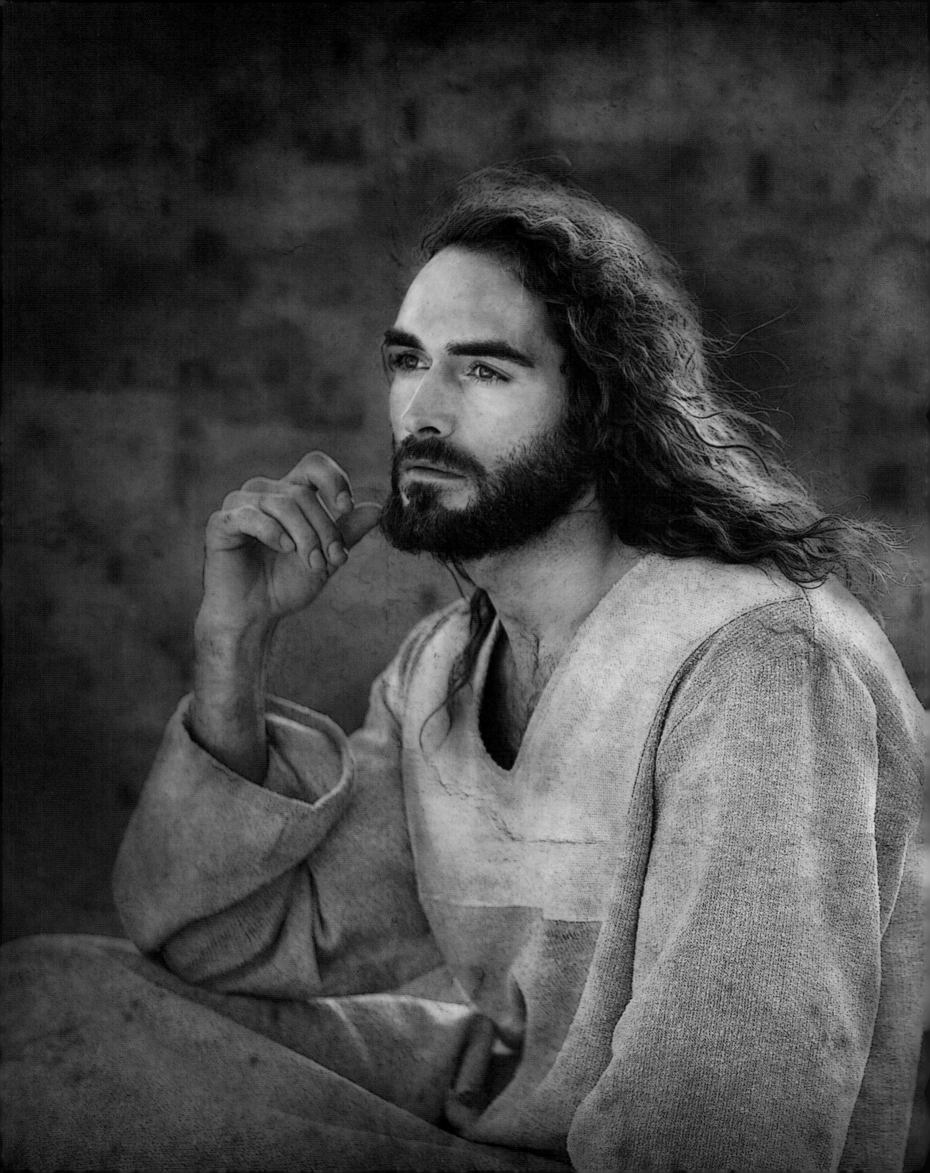

Messiah III

In the 23rd Psalm, King David writes, *"He leads me beside quiet waters, He restores my soul."*

Jesus often called "time out" to spend quiet time in solitude, in prayer and in conversation with His Father. During these times, He let all of the woes of life empty out so God could fill him up, renewing and restoring Him with peace that "passes all understanding."

This exercise is available to us, too - all day, every day - when we allow Him to lead us to quiet waters where He will restore our souls.

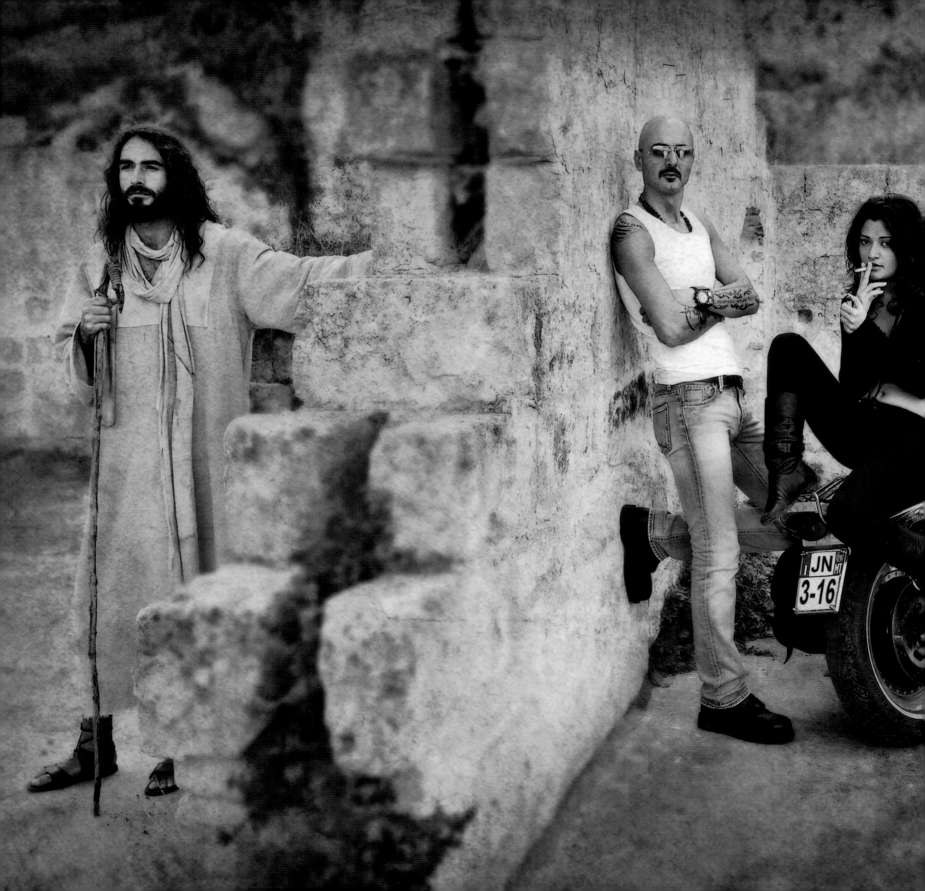

A STEP AWAY
Heaven and hell.
Where a just God draws the line.

People have asked, "If my God is so loving and kind, why would He allow some people to go to Heaven, while letting others go to Hell?" I respond by saying that I do not believe that God has a scoring system for rating "when good is good enough to go to heaven" and "when bad is bad enough to go to Hell." God knows that we will all fall short of the standard created by His Holy nature.

Rather than thinking in terms of a wall between "good enough" and "bad enough," think in terms of everyone's sinful nature being "incompatible" with God's holiness.

Jesus is, so to speak, "God's line in the sand." Those who seek the light of His true nature and immortality will stand with Him. Those who prefer the darkness of the world's lies will not. Although God wants an eternal relationship with everyone, He only makes the offer, we must make the choice.

John 17: 20-26

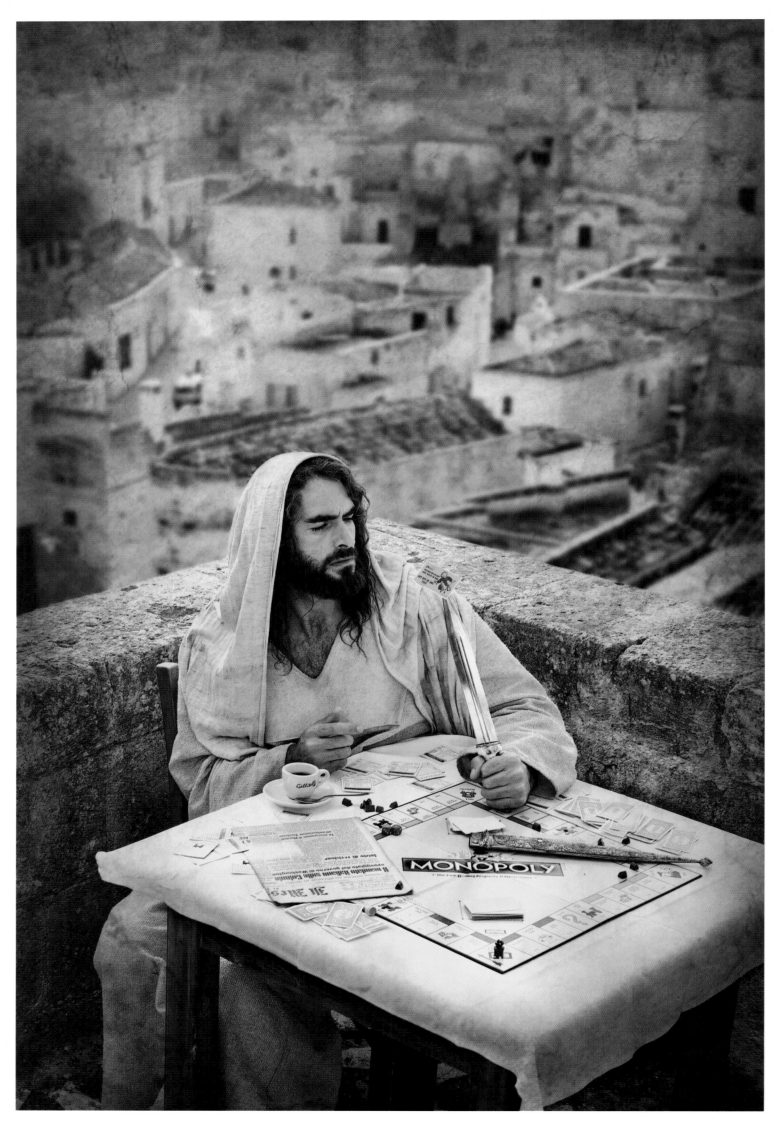

SALVATION
Confession from the heart?

I question the simplicity of the Christian invitation to accept the gift of salvation; "Just accept Jesus as your Lord and Savior" and you will have it all - redemption from sin and a seat in Heaven. Please do not misunderstand my intentions — I actually do believe the acceptance of His gift can be that simple. However, allowing Jesus to be the true Lord of your life is about "a new way of life," not just a means to avoid a date with Hell.

Throughout Jesus' teachings, He tells us about the commitment we must make and the difficulty there is in following Him. He talks about "choosing between two masters: Him or money and possessions and about the "narrow gate" we must pass through. He states that, *"he who endures to the end will be the one who is saved."* It sounds like there may be more to this salvation thing than just a simple "Yes."

There are times when I feel we short-sell the coveted gift of God's grace as a "GET OUT OF JAIL FREE" card." How many people do we see whose actions seem to say, "Now that I have accepted Jesus, I can get on back to the party." Then, they go on living their lives as if nothing has changed?

God is not fooled, for surely He does not take the death of His Son so lightly! He knows the difference between a confession of the lips and a confession of the heart!

Romans 10:9

Sassi di Matera

The Sassi are houses dug into the rock itself. Many of these "houses" are really only caverns, and the streets in some parts of the Sassi often are located on the rooftops of other houses. The ancient town of Sassi di Matera grew in height on one slope of the ravine created by a river that is now a small stream.

In the 1950s, the government of Italy relocated most of the population of the Sassi to areas of the developing modern city. However, after renovations, people continued to live in the Sassi, and according to the English Fodor's guide: "Matera is the only place in the world where people can boast to still live in the same houses of their ancestors of 9,000 years ago."

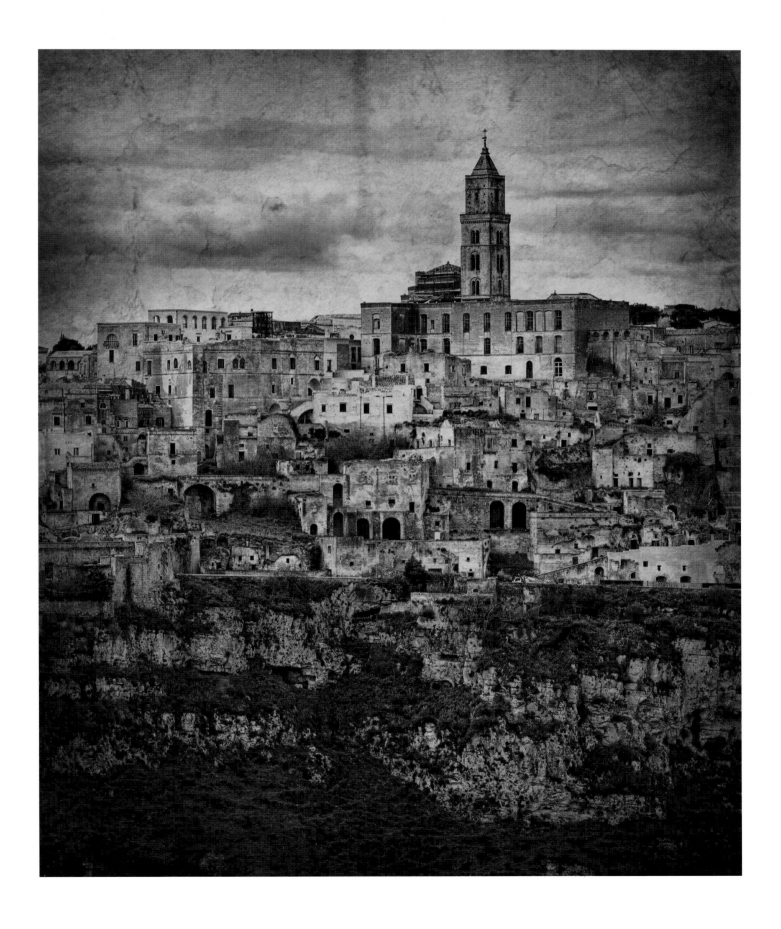

Messiah VIII

Many of us live our lives on the "when and then" theory. "When" this happens, "then" I will…

Jesus' message is "now." In His famous "Sermon on the Mount," He tells us, *"Do not worry about tomorrow, for tomorrow will worry about its own things."* In other words, do not miss the joy that is in front of you this day, while you are planning for tomorrow.

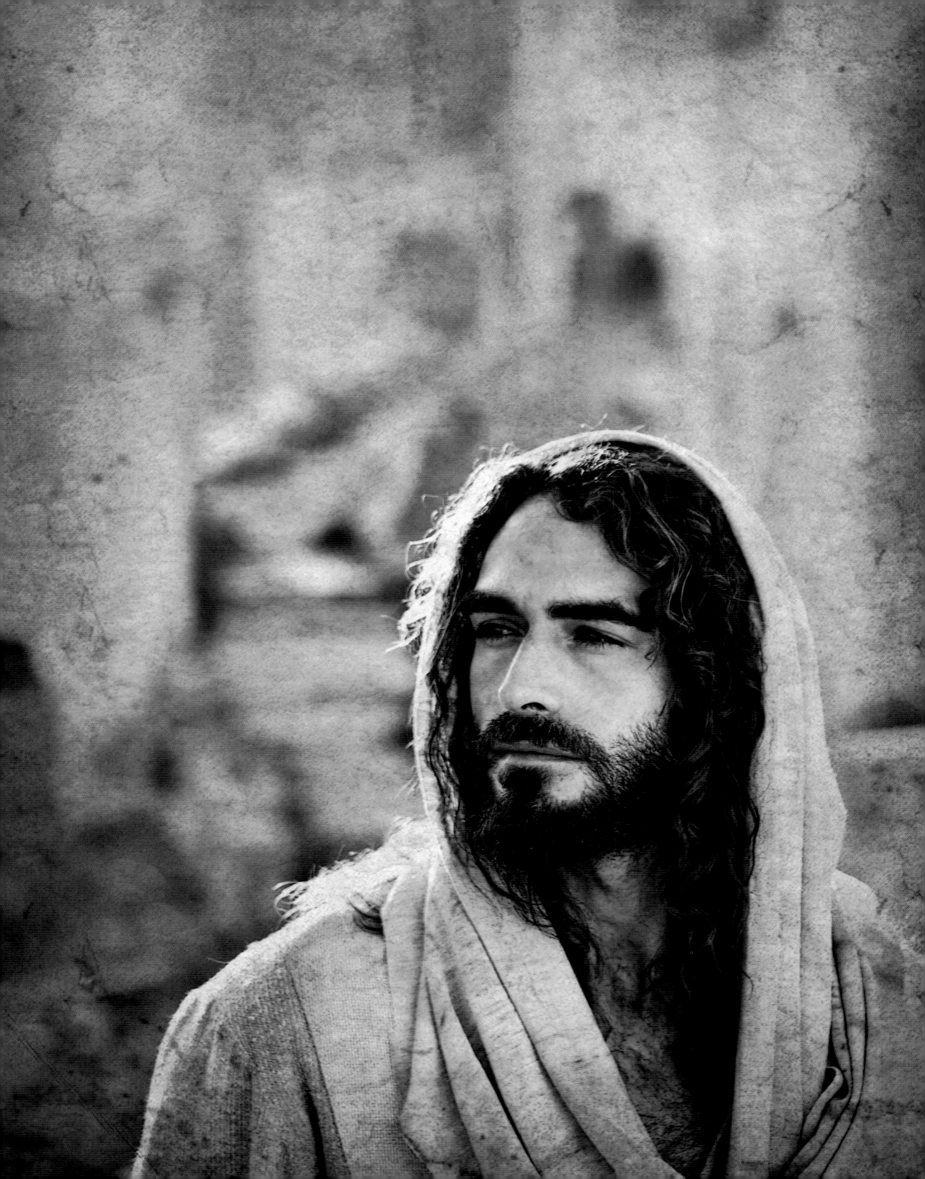

SAFE HARBOR
The light to guide our way.

Most of us love lighthouses. We photograph them, paint pictures of them and explore them. Perhaps it is their purpose that attracts us most. They are beacons of light inviting ships in the night to a place of safe harbor, a place of calm from a storm, a place of rest for the sea-weary. They also serve to warn sailors of the dangers of a nearby coast.

Jesus said that He was *"the light of the world,"* and that He had come to *"bring light to the darkness"* and to *"guide our way to the truth."* Like the lighthouse, Jesus, through His spirit and through His teachings, is available to guide us to safety, to warn us of danger and provide a safe harbor, a place of calm and rest from the storms of life.

John 9:5

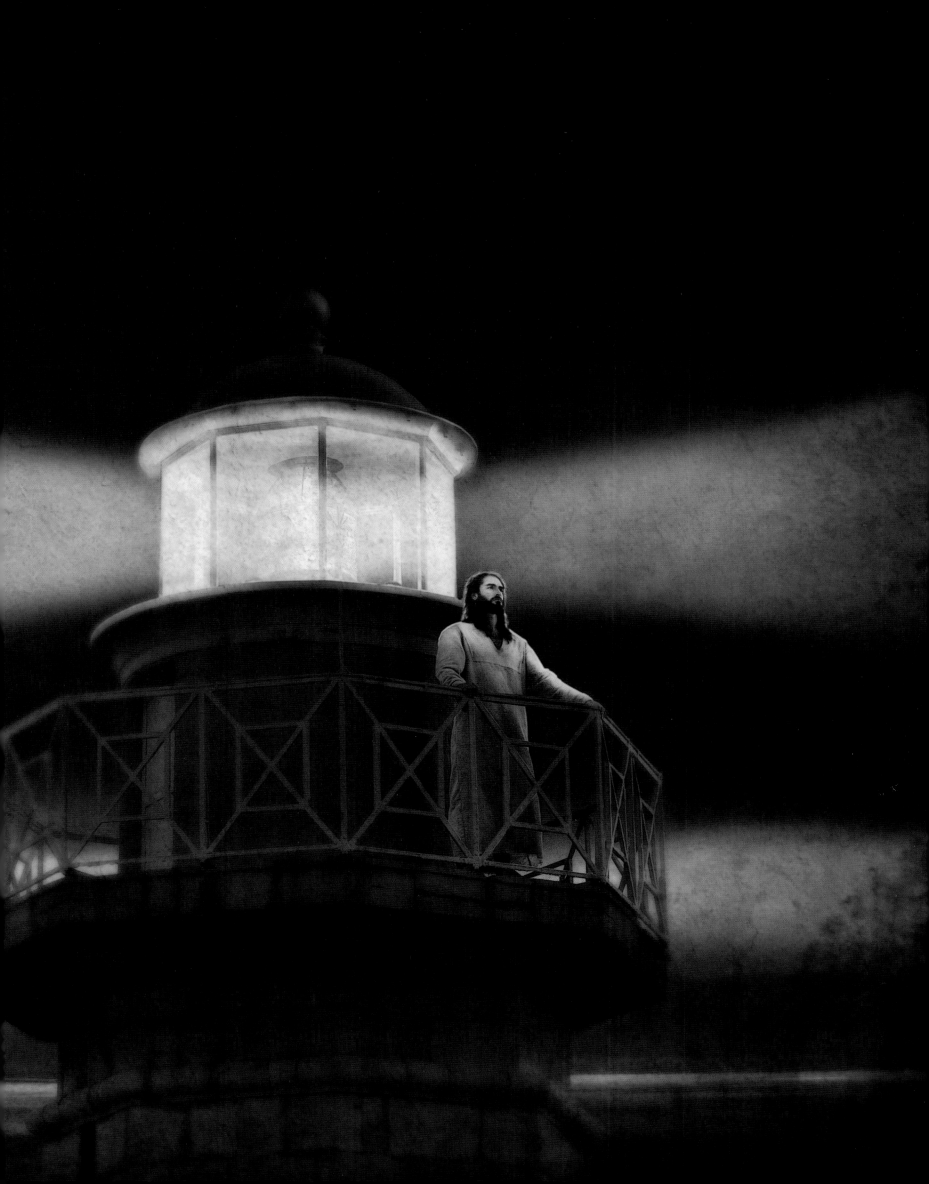

HOLY ABUNDANCE
God's provision gone awry.

The World Health Organization reports that two-thirds of the world's population is under-fed or starving. Every day, 16,000 children die from hunger-related causes. That is one child every five seconds or about nine children in the time it will take you to read this message.

When I hear statistics like this, I immediately think of far away places like India and Africa. And then I learn that, in the United States, one out of every eight children under age 12 goes to bed hungry every night.

There is a story about a man who stands on a hill overlooking a refugee camp. Seeing the starvation and death, he turns his face skyward and screams, "God, how could you let this happen?" God responds with, *"How could you?"*

We have the means to fix this. The world's poorest could have their health and nutritional needs met for less than 25% of what Americans spend on clothing each year.

The issue is not a lack of abundance. It is simply a lack of distribution. How many children will die today while I sit on my savings account? It is a painful question to ponder.

Matthew 6:19–21

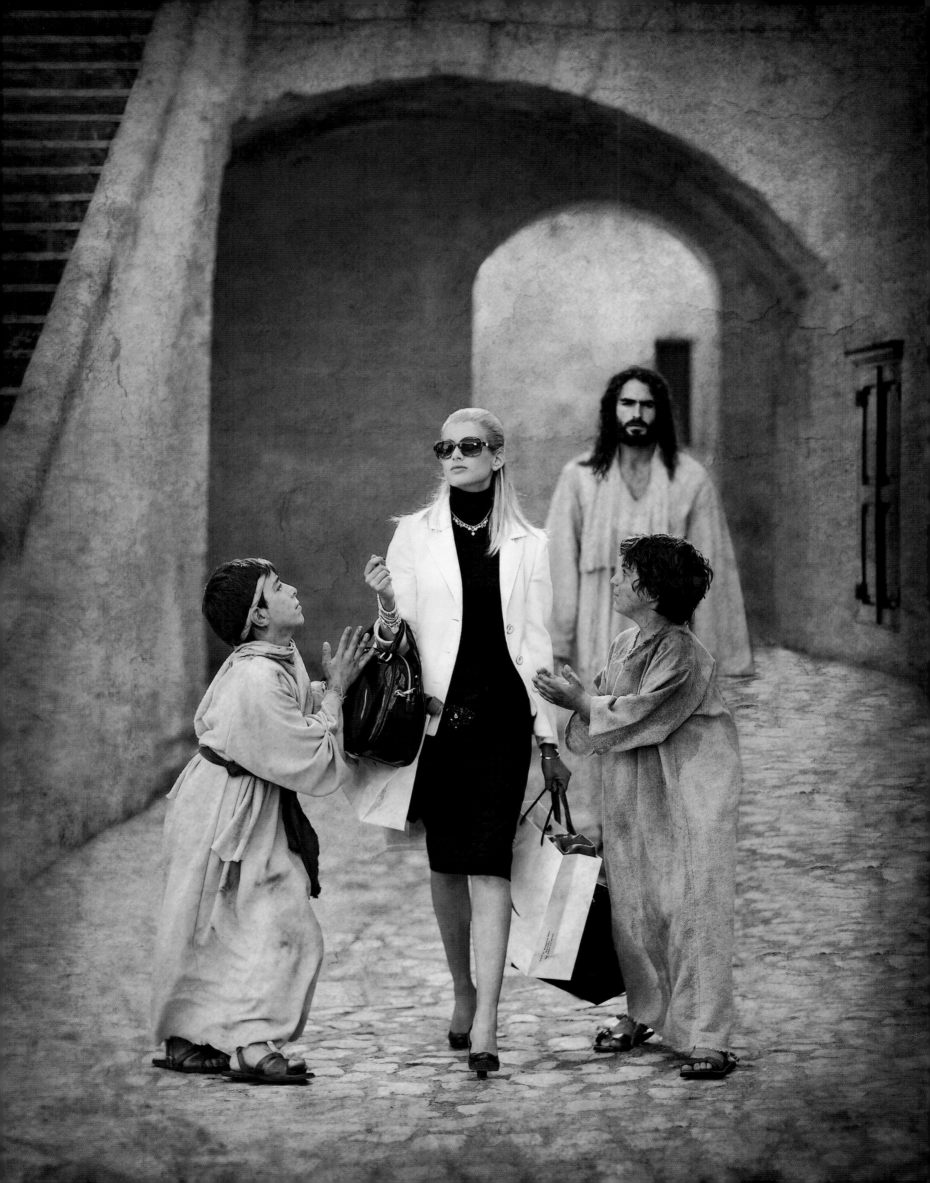

EMBRACE
A Savior for all.

*J*esus did not come to start a religion. He came to start a revolution — a revolutionary way of living through understanding God's plan for mankind. Jesus did not plan to usher in the Methodists or the Muslims, the Baptists or the Buddhists. Yet, during the 2000 years since He walked the Earth, we have found ways to formally gather based on our personal views of God's single truth.

Jesus' statement, *"No one comes to the Father except through Me,"* has been accepted by Christians to mean that only those who accept Jesus as Lord will live with Him in eternity. Yet, if Jesus came as the Savior of the world, for all people, for all nations, where does that place all other religions? Assuming His statement is properly understood — that everyone must come through Him to spend eternity with Him — then what is God's plan for the two-thirds of the world's population that is non-Christian?

We are God's plan! For everyone who knows the Gospel story, Jesus commands that we *"go tell all nations the good news."* If we will not take time to love and reach out to the people of other religions, how will we ever find a way to share our faith with them?

Matthew 28:19

STAYING FOCUSED
God's secret to success.

*P*eople who excel at accomplishing things are usually focused on *what* they want to achieve rather than *how* they are going to achieve it. In reality, very few people know *how to accomplish* their desire at the beginning of a journey. It is *what they desire* that guides their course.

Jesus remained focused on His mission and *what* His Father sent Him to do. At times, He was tired and bewildered and, in the end, frightened as any man would be. Yet, He knew the cost of failure was unacceptable and would mean the loss of all mankind.

Are you focused on *what* God wants for your life or are you frozen while you try to figure out how you are going to do it?

God will never give you a dream without providing the instructions for making it come true.

Matthew 6: 25-24

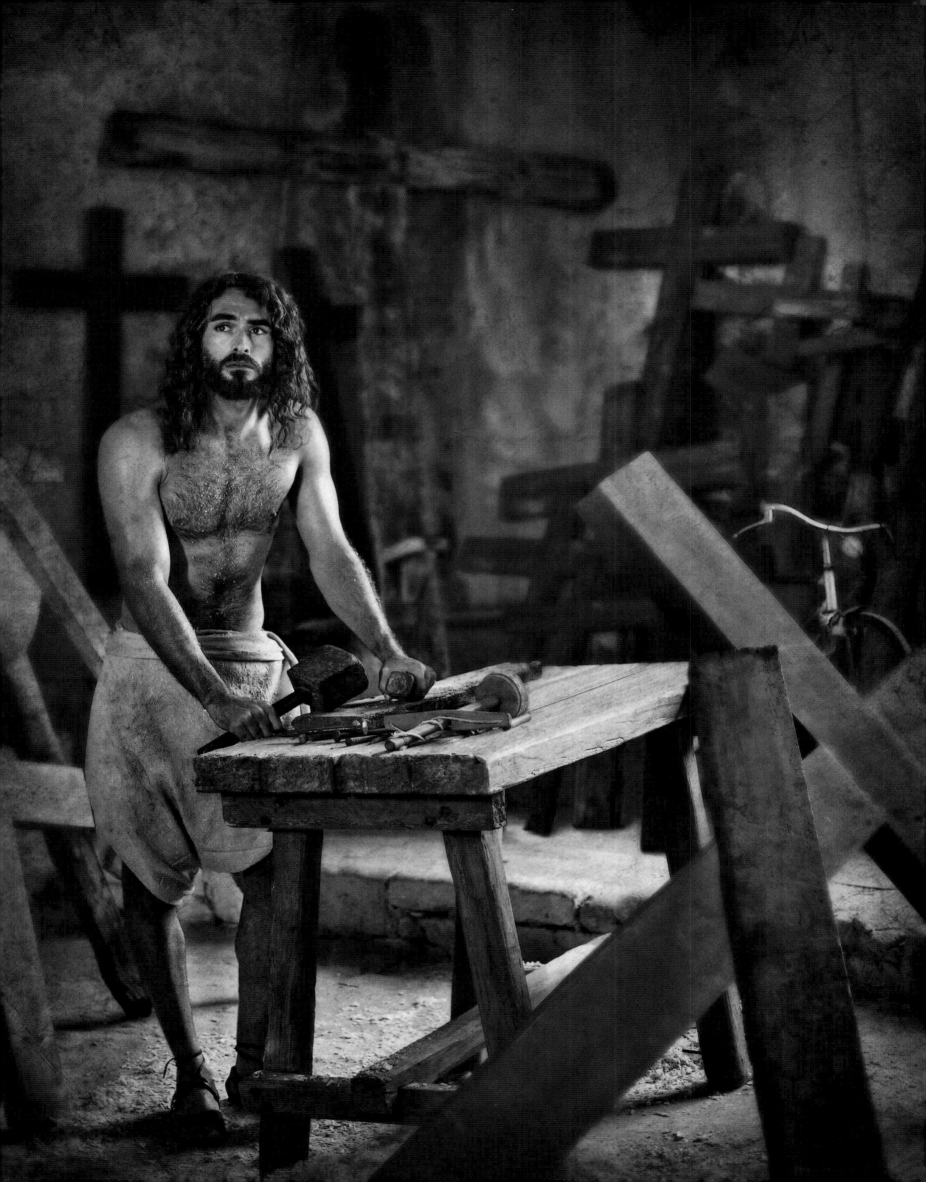

THE SECOND MILE
The joyful gift of forgiving.

*W*here does a mother harness the strength to stand in a courtroom and forgive the man who murdered her daughter? How do Jews ever forgive the Nazis for the Holocaust?

Jesus' teachings on this subject were revolutionary: *"Love your enemies as yourself. Pray for those who persecute you. Forgive people seventy times seven."* Jesus reminds us that, just as God forgives us, we are expected to do the same for others.

His teachings on forgiveness, however, are often more beneficial to us than the people we forgive. Jesus knows that our feelings of anger, resentment and hatred will not hurt the other person to the degree they can destroy us.

So, He wants us to let go of these feelings by forgiving. Just saying, "I forgive you," releases us from emotional, physical and spiritual bondage. It sets us free to move on with life and His glorious plan.

So, forgive and then, let it go.

Matthew 18:21–22

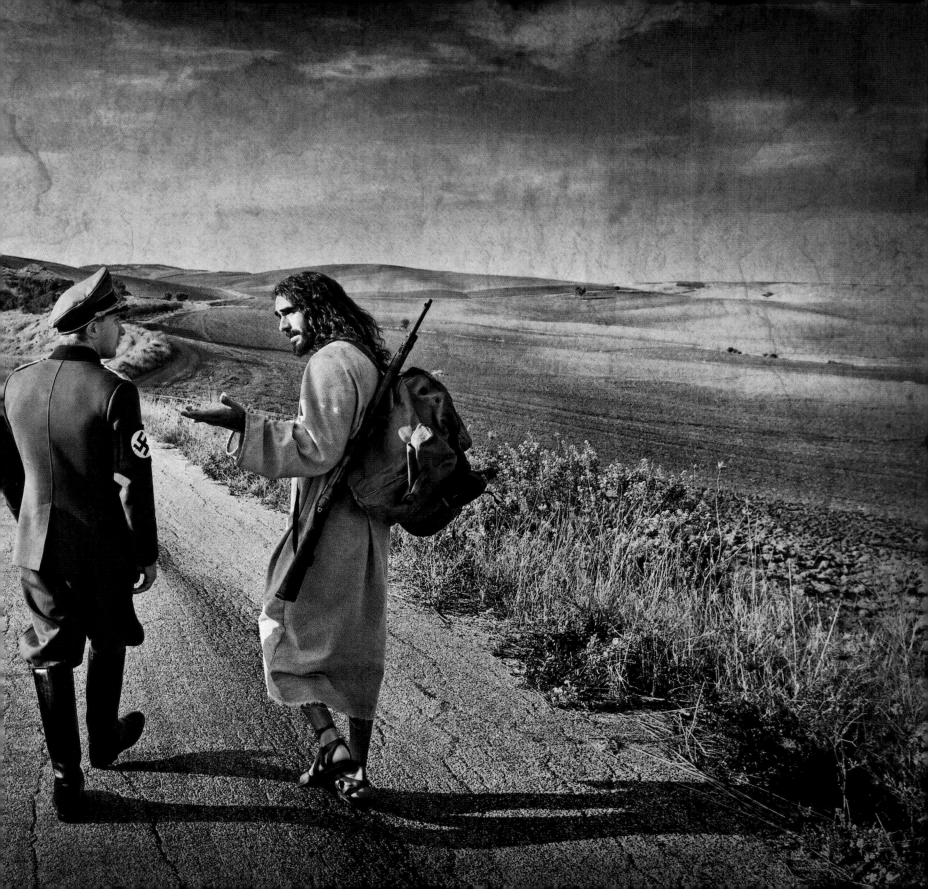

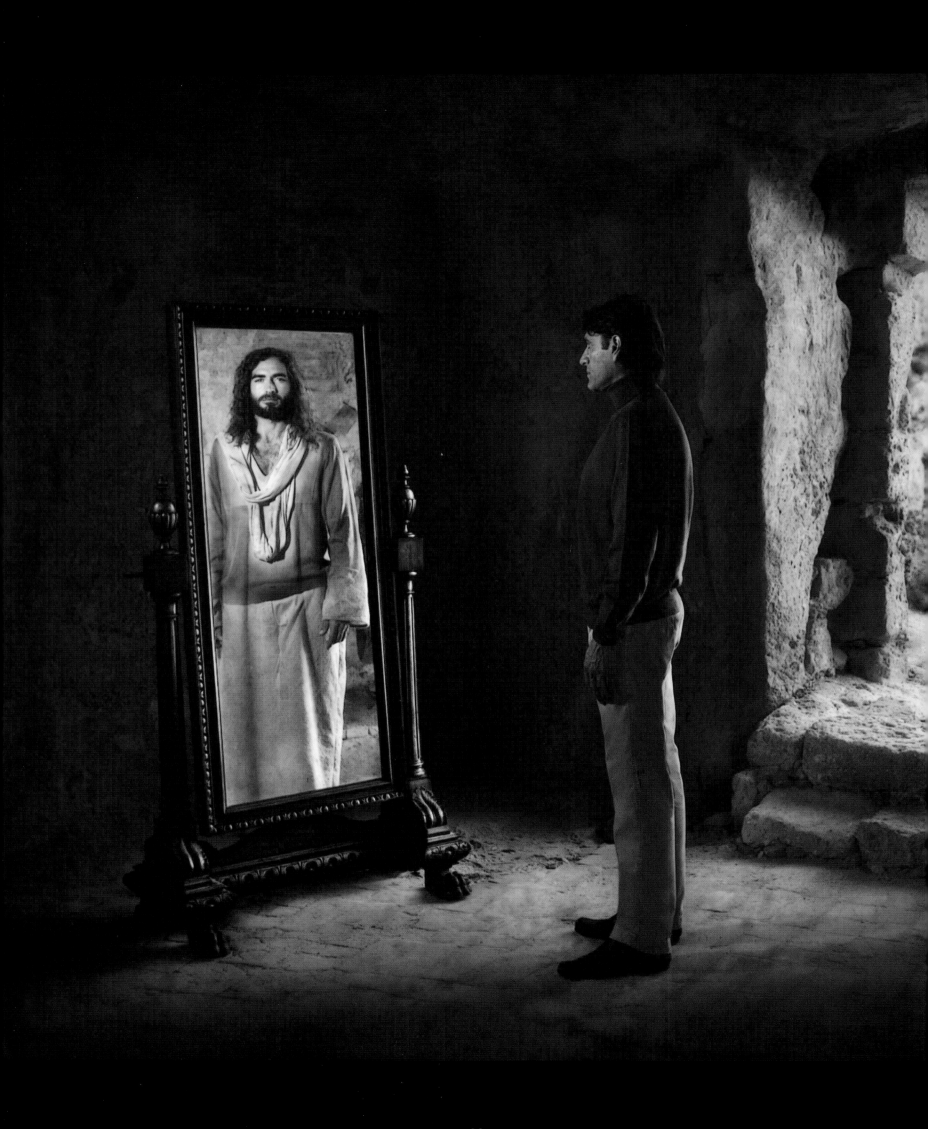

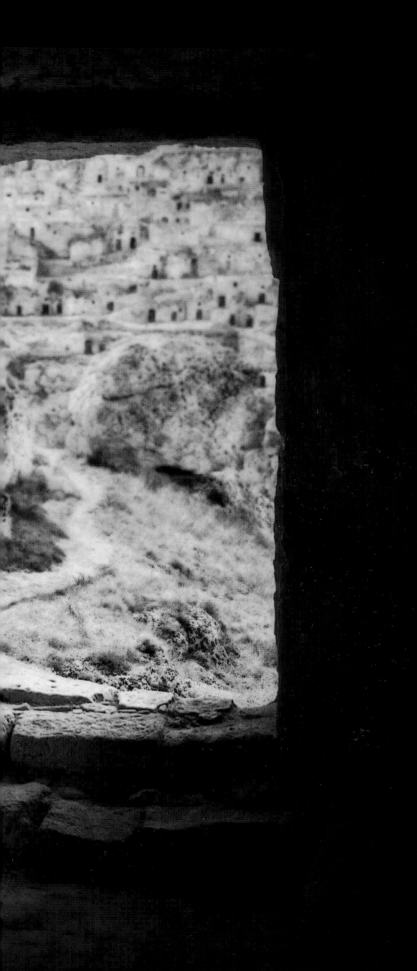

METAMORPHOSIS
Uncovering the Christ in you.

*T*hinking back over my life, I reflect on many things that I wish I could take back, change or erase. There were many days I looked into the mirror and was not pleased with the man who was looking back.

From the very beginning of the Bible, God tells us we were made in His image, and He has great plans and a perfect design for our lives.

So, how do we discover His perfect plan? His answer: *"You will find Me when you seek me with all of your heart."* To the contrary, if you don't seek Him, you will not find Him. When you do seek Him and begin to uncover His divine majesty, the old you will begin to fade away, revealing the person He intended you to be.

2 Corinthians 3: 13–18

Messiah X

Jesus' words about "the darkness" were used to explain the anger, jealousy and lack of joy that often occupies the typical heart of man. It is a condition he wants to change. Even with a lighthouse beacon, a lantern or a powerful flashlight, He knows that we will stumble around in the darkness of this world until we allow Him to light the way.

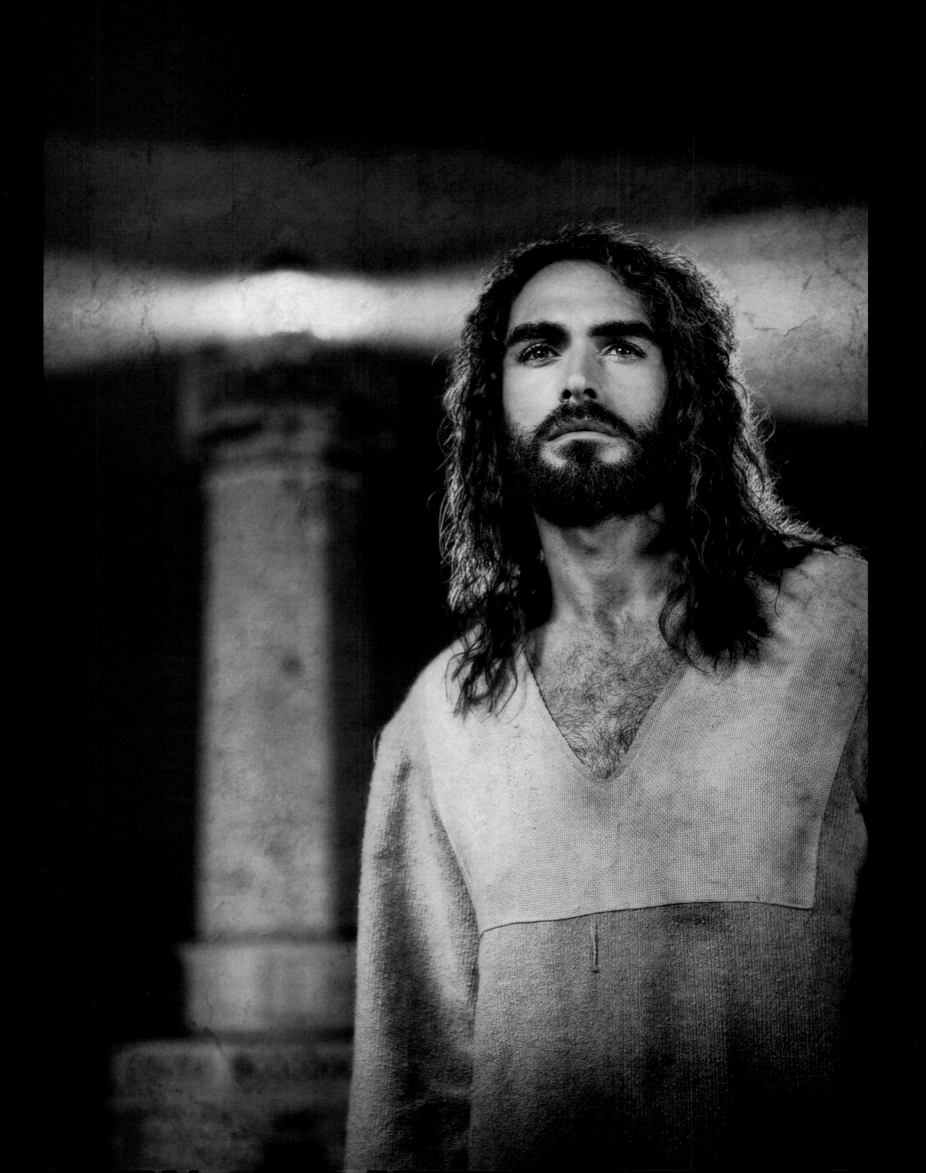

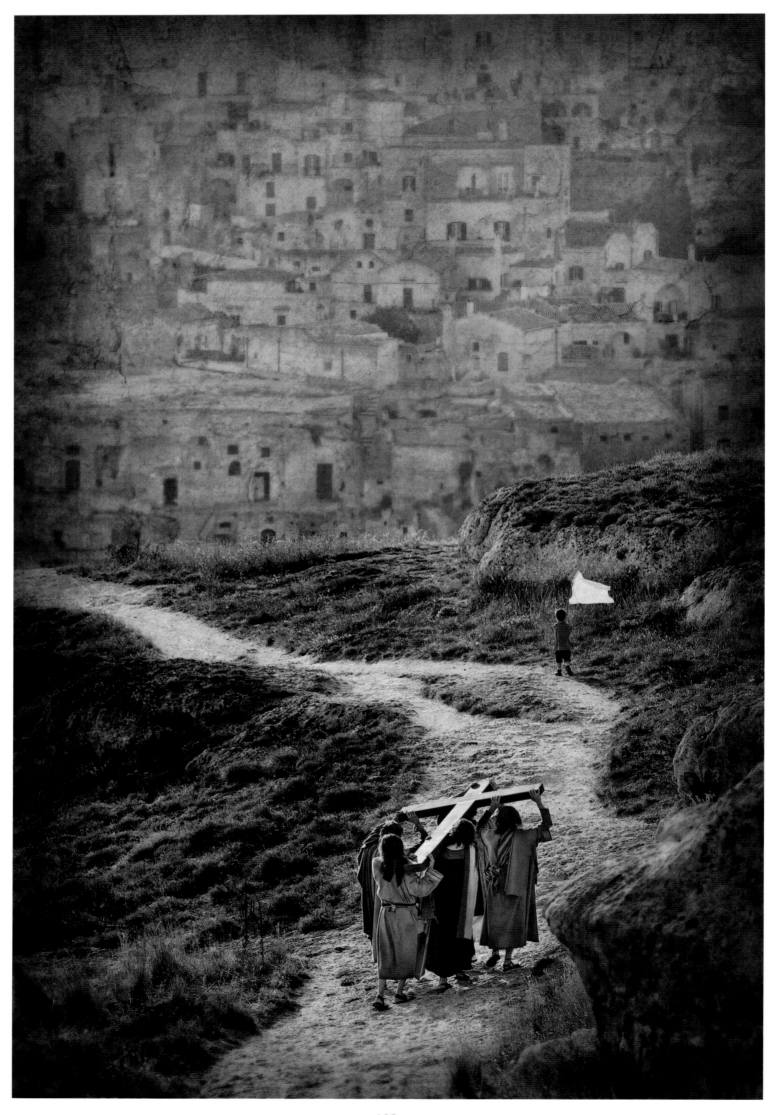

WITHOUT A DOUBT

Evidence of the Resurrection.

*T*he account of Jesus dying on the cross and rising from the dead three days later, as promised, is not a cleverly devised fable. There is, in fact, more documented evidence attesting to this truth than to any ancient history.

For me, what happened later to His disciples, is the most compelling testament to Jesus' resurrection from the dead.

After Jesus was nailed to a cross, His disciples, who believed that He was the Messiah, must have looked at each other and said, "Hey, we called this one wrong, let's get out of here." They knew the authorities would be after them next, and they ran in fear for their lives.

Yet, history shows that, of all the disciples, only one died a natural death. The others were martyred by crucifixion, boiling in oil, being thrown from a cliff, beaten to death and flayed.

No one returns to face certain death to participate in a hoax. No. There is only one plausible reason the disciples returned to almost certain execution: They had seen Jesus alive after seeing Him die on the cross.

When Peter and John were told by the authorities not to speak or teach in the name of Jesus, they responded by saying, "We can't keep quiet about what we have seen and heard."

We, too, have reason to believe.

Acts 4: 1-22

VACANCY

A cross for everyone.

*W*ho, but the God of all imagination, could take the cross, the most barbaric tool of execution, and turn it into a symbol of hope and faith, a signature of all that is good in the world?

There is a wealth of understanding to be discovered in the cross. In the historical account of Jesus' birth, Mary and Joseph arrived in Bethlehem to find no room, no vacancy, in the inn. Yet, just 33 brief years later, there was plenty of room for Jesus at the cross.

There is room at the cross for you and me in learning to die to our own needs and learning to live for the needs of others; in dying to having it our way and learning to live in His way; in dying to the darkness of this world while opening our eyes to the light of God's world.

Jesus, the man, died on the cross. Jesus, the Savior, lives. Maybe we should book our reservations now!

Matthew 10: 38-39

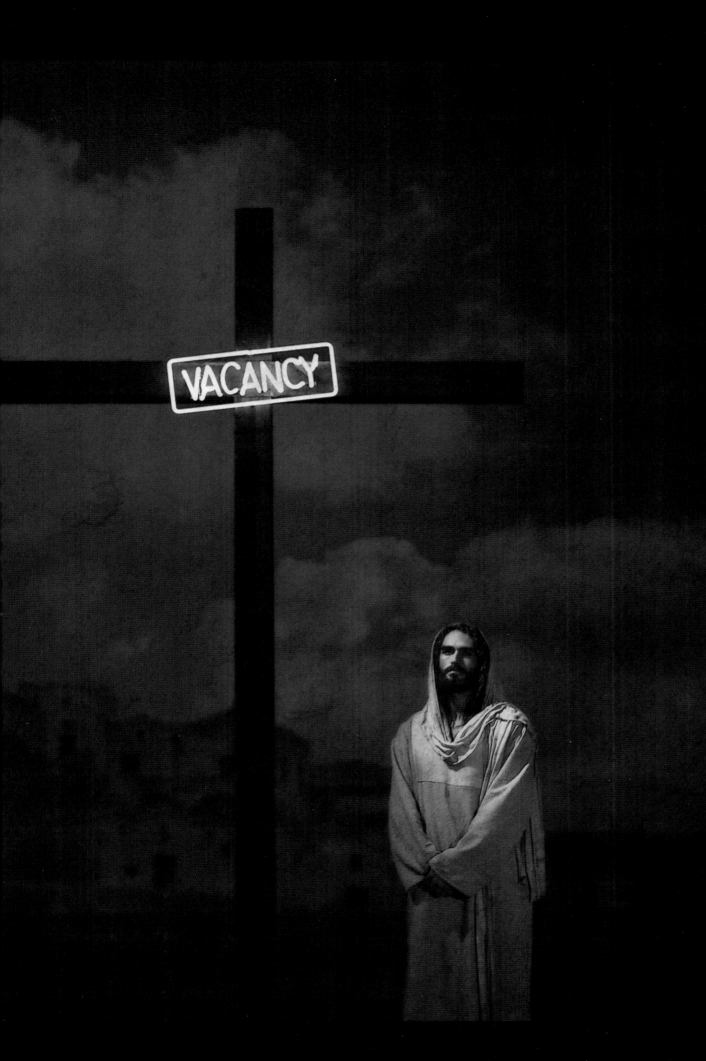

JOIN THE JOURNEY

Journeys with the Messiah began as a project. It soon became my personal journey - one to understand Jesus' messages in ways I never imagined. Now, I know that God is sending me on a mission to share my discoveries with you and the rest of the world.

These unique images, accompanied by their easy to understand, yet thought-provoking messages, are touching hearts around the world as they are shared through our Journeys book, DVD, posters and website (TheJourneysProject.com). They are also being shared as I present them in churches using a powerful audio/visual presentation.

I know you, too, want to see the joy of the Gospel shared around the world. So, we are asking you to join us on our mission, ***not by making a donation***, but simply by commiting to own one of these beautiful and powerful images depicting the messages of Jesus Christ.

The editions of each piece are very limited - *only 99 of each "Parable" or story images and only 999 of each of the "Messiah" or Christ images,* spread equally across three sizes - 23 inch, 28 inch and 34 inch. Each image is of museum quality on 100% cotton rag paper. Opening price points are $499 for Messiah images and $999 for Parable images.

Whether you hang this work of art in your home or office or make it a gift to your church or minister or friend, you will be investing in The Great Commission as you join us to share the Gospel. It will also be an investment in eternity.

There is a world hungry to hear God's voice. So, please make a commitment to own one of the images by contacting us today. It will be greatly appreciated by all of the people who have worked to make *Journeys with the Messiah* a reality and all of the people who will hear and see the messages of Jesus in this unique presentation.

God bless,

Michael Belk

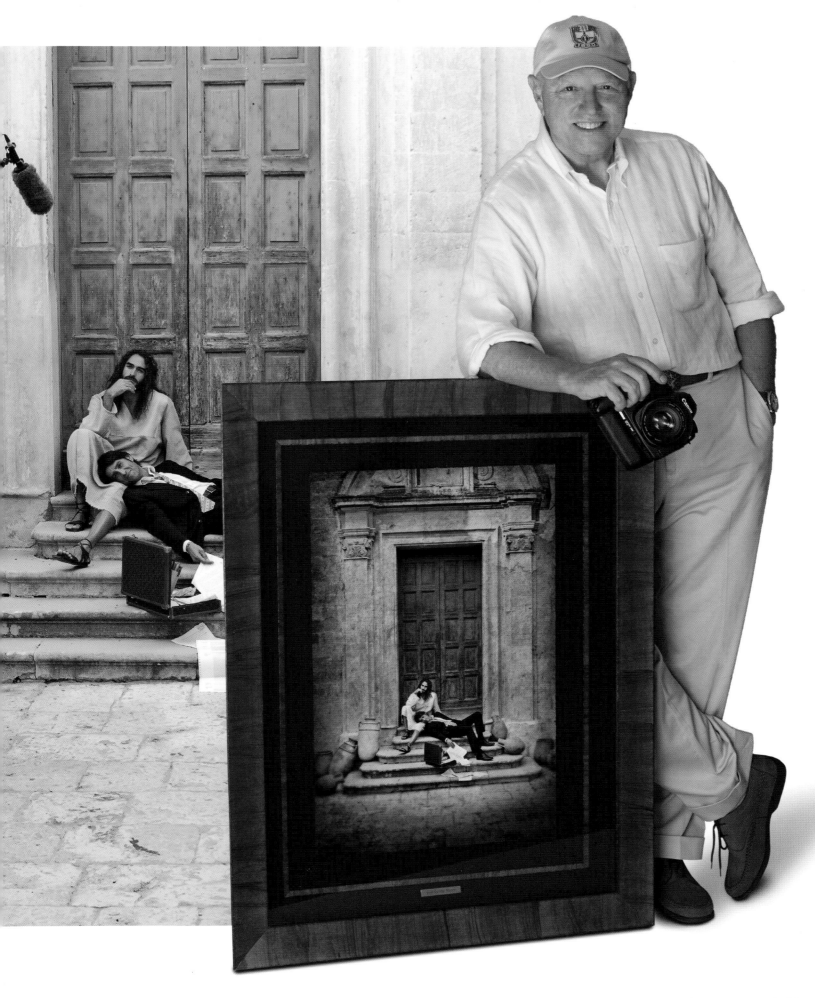

A NOTE OF THANKS.

One can never go it alone on a project of this magnitude. Brian Shepler has blessed me with his knowledge, friendship and strategic thinking. (He has also heard me whine a lot!) Mark Hendrick has been my dear friend for years, taught me most of what I know about digital image processing and assisted me in Italy. His expertise shows throughout this book. Harriette Crain, my friend and mentor, quietly introduced me to Jesus as I know him today and Ronnie McBrayer inspires me to stay on the journey. And to my brother, Richard, a man after God's own heart, your support has meant everything to me.

After Francesco Foschino helped us get started in Matera, Maurizio Antonini of Interlinea Film in Rome made it all come together. Gianni, Nunzia, Sandra and Gao added to the creation with lighting, props and set decoration, magnificent costumes, wardrobes and casting. My dear Antonella Foschino resolved the language barrier with her perfect translations. And, a very special thanks to the City of Matera for allowing their Sassi di Matera to be the stage upon which we created.

Additionally, we were blessed to have the film crew of David Nixon, Kim Dawson , Bob Scott and Vincent Nuccio on set capturing the footage for all of our "behind-the-scenes" video and more.

Finally, thanks to my friends who "invested in an idea" by purchasing images, sight unseen.